D1582470

Graham Crowley

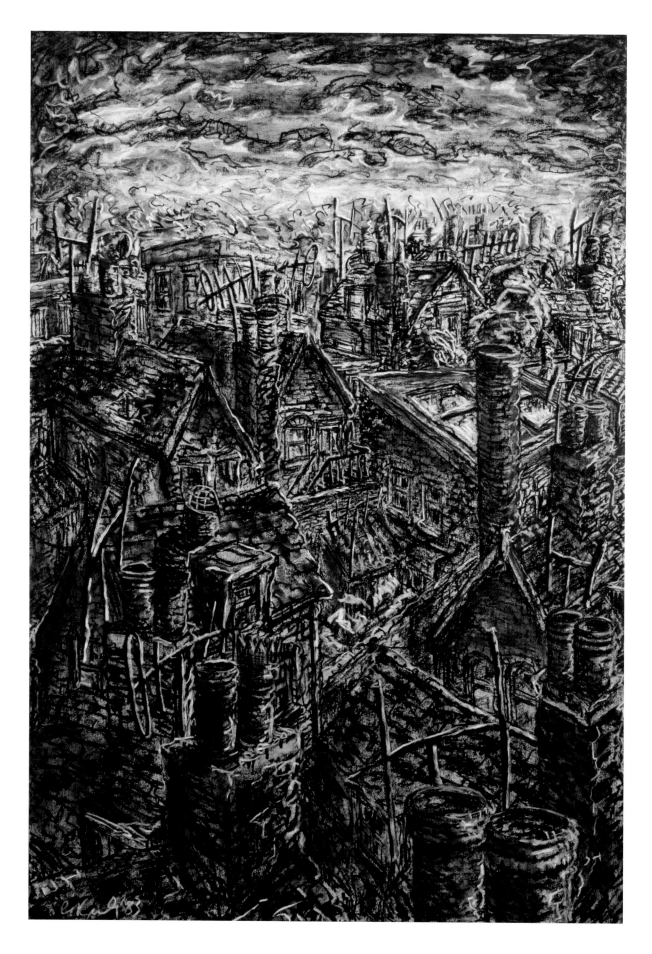

Fig. 1 · **The Sprawl (No. 3)** · 1983
Compressed charcoal and conté on paper · 100 x 67.5 cm
Private collection

# Graham Crowley

## Martin Holman

Lund Humphries
in association with Broken Glass

# Contents

THE HENLEY COLLEGE LIBRARY

# Ackowledgements

The approach taken by the extended essay borrows from the observation of the eminent British historian, C.V. Wedgwood, that history is lived forwards and written in retrospect. Consequently, I have thought it important to examine Crowley's work both with the privilege of hindsight and through its critical reception when first exhibited. The spread of different voices heard throughout the text will, I hope, remind the reader not only of what was written by critics but also that their comments appeared in national newspapers and journals when measured discussion of contemporary trends in visual art could be followed in their pages. Both reflect the regard that Crowley's work has been held in and the place he has occupied as an essentially independent figure when art was still perceived as having its mainstream and marginal tributaries.

For their assistance with different aspects of research and production that combined to make this book a reality, I wish particularly to thank David Austen; Tony Carter, principal, and the trustees of the City and Guilds of London Art School; Sally, Robin and Pearce Crowley; Srijana Gurung; Dag Holman; Lucy Myers and Lund Humphries; Phil Pound; and John Talbot. David Bloomfield has brought to his thoughtful design of this publication his professional acumen and many years' familiarity with the artist's work and enthusiasms. For his early support for both Graham Crowley and for me as an aspiring writer, I wish to remember here the late Edward Totah.

I have been fortunate in the friends and artists whose encouragement and interest helped propel me through the pleasurable and stimulating task of being reacquainted with paintings not seen for many years and with the ideas that shaped them. Of these Tim Allen, Sue Arrowsmith, Maria Chevska, Ian Davenport, Jeffrey Dennis, Emma Hill, Paul Housley, Robert Mason and Danny Rolph especially deserve mention.

While I was writing this book, my wonderful mother died. Gratitude for her unfailing belief in me, especially at times when I could not believe in myself, was a spur to completing this project, I hope, to the standard she expected me to achieve, despite the long shadow of grief.

The most sustaining element, however, was the commitment of Graham Crowley to what we had embarked upon and his request that, after knowing each other for 25 years, I should be the writer to survey his career.

Martin Holman

*'I believe that it is possible to make an art that is both entertaining and substantial. Theatre and cinema already accomplish this.'*

Graham Crowley quoted in
*The Image as Catalyst:*
*The younger generation of British*
*figurative painters* (exhibition catalogue),
Ashmolean Museum, Oxford, 1984, p. 9.

# Long Player

*'Crowley has at last committed himself to what he always promised to be, a narrative painter with an eye for the vernacular.'*[1]

Graham Crowley regards painting as demanding and exacting. He lays out a conspicuous amount of time in the physical effort of making a new work, to exact from his skill the visual result he seeks. He claims, however, that by far the greater demand is to ensure that the material transformation of the surface coalesces with his idea for an image. That symphysis, the junction of parts, is critical because it communicates meaning.

Painting is this artist's defence against anxiety. His imagery attests to a protean range of interests and aspirations. The extent of that range contributes to the changing modes of expression that he has developed during 35 years as a professional practitioner. He has not been afraid to change tack once the possibilities of one line of investigation have been exhausted for him. He has called this way of working his 'stylistic infidelity'.[2]

That this infidelity of means has sustained a remarkable consistency of ambition for the unique potency of painting is one theme of this book. Another is to examine Crowley's commitment to the transformative effect that art can have on individuals given the opportunity to engage closely with it. It accounts for his involvement in public art and in education throughout his career, and also for his belief (viewed as controversial in many sections of the art world) that painting should be accessible to audiences with different backgrounds and levels of experience in the arts. The debate which his attitudes arouse has been evidence, in his view, of the rupture completed by late modernism of a common sense of meaning between image and spectator that ran through art's history.

There are unexpected historical parallels between Crowley's expectations of his art form (and of the abilities of his viewer) and those of William Hogarth and Charles Dickens. Like Crowley, Hogarth and Dickens were deeply involved with the world they lived in – as participants and not merely as observers. Hogarth risked antipathy with stringent satires; the establishment may not yet have forgiven him for challenging convention, despite being a painter with matchless skills and a deep sensitivity for paint. Dickens elevated popular episodic fictional story-telling to a high level and through the invention of protagonists found therapeutic release for the tensions of his own life experience. 'I do not write resentfully or angrily: for I know how all these things have worked together to make me what I am.' Dickens' comment about himself has a resonance for Crowley.[3]

∙

In 2004, Graham Crowley contributed to an exhibition at the London venue, 39, of works by 50 artists on the theme of a pub crawl. Participants were asked to produce on uniformly-sized panels of medium-density fibreboard (MDF) that the organisers provided an image inspired by the name of a London pub. Not all the works in the show were two-dimensional; some were built up from the surface. But most were paintings, including Crowley's, which was called *The Drunken Duck* (figs. 2-3).

A pub crawl is defined as the act of one or more people drinking in multiple public houses in one night, normally walking to each one between drinking. The pastime is predominantly undertaken by men, which is the one element of its definition that did not fit either with the exhibition (as women artists were as well represented as male ones) or with Crowley's artistic, political or social characteristics.

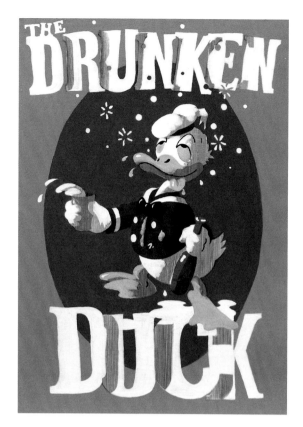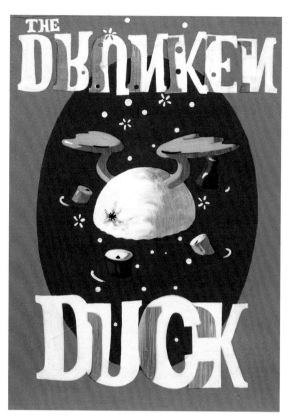

Fig. 2 (left) and Fig. 3. Front and back of The Drunken Duck, 2004, two-sided painting, enamel on board, 42 x 30 cm. Made for Pub Crawl, the exhibition at 39, London, July 2004

In other respects, however, the circumstances of the commission were very appropriate to Crowley – except the alcoholic. A pub crawl is symbolic of camaraderie; it has working-class origins; it has historic and generic resonances that reach back as far as Chaucer; whatever the status of those taking part, the crawl has low cultural associations that border on disorder; and it involves being part of the activity rather than being an observer in the stalls who might then pronounce on the performance of the revellers.

Crowley's choice of pub name was *The Drunken Duck*. The painting that resulted is both typical of Crowley and characteristic of an approach that the artist has applied with notable consistency in a professional career that began at the start of the 1970s. It differs from his preferred pattern of working by being a "one-off" rather than an element within a series sustained over a period. It is painted in Humbrol gloss enamel paints in imitation of pub signs rather than indicative of Crowley's technique (this painter has pursued technical knowledge and ingenuity beyond the scope of many of his peers and successors) and is primarily humorous.

But *The Drunken Duck* is also symptomatic of Crowley's outlook. That he should deal seriously with an opportunistic invitation to make new work, the nature of which was dictated by others rather than being an expression of his own current preoccupations, exemplifies his willingness to collaborate with fellow artists. On this occasion, the exhibition was conceived by John Strutton and Alan Miller.[4] Miller in particular was a practitioner in tune with Crowley's ambitions for painting since the two first met, in 1973, when he became a tutor in painting at the Royal College of Art where Crowley was studying.

Crowley admires in Miller, his senior by nine years, and later saw in Strutton, a natural inclination to live 'in the culture' of which they felt a part. Lacking the pretension, as Crowley sees it, of institutional convention or a slavish adherence to the mainstream, they bring that commitment into their work – as

art school tutors as well as professional artists – as a consequence of the lives they live and only partly because they are artists well-informed about the social responsibility of art and its parallel existence as an academic pursuit.

That demeanour informed the signs created for *Pub Crawl* and the people selected to make them. Crowley's is candid and almost matter of fact, a depiction of Donald Duck, bleary-eyed and clutching a glass and bottle. Whirling around his head is an alcoholic haze spelled out in a cartoon notation that is immediately legible to the viewer. On the reverse of the sign Donald appears again, this time upended in an oval of blue that is read as water because only his webbed feet and feathery backside are visible, and half-submerged drinks cans and bottles bob on the surface around him.

Crowley admits that the commission was an inevitable opportunity to play with and subvert the popular and cultural position of the Walt Disney character, inevitable inasmuch as the offer played to Crowley's instincts. Having chosen the pub name, the cartoon figure quickly came into his mind. About his schooldays in Essex in the early 1960s, Crowley describes himself as an 'attention-seeking' child who made drawings of favourite characters from comics to please his classmates. He could draw well as a schoolboy and this later commission reminded him of the pastime of that particular pupil, one who did not feel academically talented but who preferred the company of clever children.

The young Crowley became adept at entertaining himself, at finding distractions and developing intense interests to feed his natural curiosity and to keep him out of harm's way, at home and at school. Watching animated cartoons was one of his favourite occupations as a child. His father built televisions as a hobby in the early 1950s; he had had experience of cathode-ray tube technology in the second world war. So Crowley was one of the first recruits to the pioneer 'television generation' and could watch the output of children's programming on the BBC and commercial channels from a young age.

Another pleasure was poring over British and imported American graphic comics. Magazines about cars and motorcycles were a particular pleasure. Out of the highly detailed technical drawings of vehicles, aeroplanes and farm machinery, by Lawrie Watts especially, came his earliest notions of an 'artwork' as a source of visual pleasure and of wider knowledge unlocked from complexity by the viewer's investment of interest and attention. Drawing the few mostly pre-war cars on the streets of Romford as he was growing up, he imagined designs of new models based on Chevrolets, Cadillacs, Ferraris and the Pegaso Z-102, the Spanish sports car that in the 1950s rivalled Alfa Romeo, that were illustrated in the motoring press. He remembers vividly being praised, as a six year old, by a teacher who displayed to the class the car he had made out of matchboxes stuck together with glutinous brown LePage glue. Being noticed pleased him and may have compensated for not often being indulged at home and school.[5]

Romford offered few distractions to the young teenager. The first town of significant size beyond the eastern outskirts of London, its population had tripled in 30 years by 1965 and its amenities had not yet caught up with this dramatic growth.[6] Crowley's father, an electro-mechanical engineer in the London office of Kelvin and Hughes, the marine engineering firm that supplied the Ministry of Defence, had advanced himself socially and geographically from his origins in Whitechapel. He and his wife encouraged their children (Crowley has a younger brother, Stephen) with often stern observance of what they felt were acceptable standards of behaviour, although Crowley found that their unpredictable response to perceived misdemeanours made their intentions hard to read. His parents took no particular interest in their son's education, but they turned down the scholarship offered him to attend a prestigious grammar school and moved the family from Chelmsford to enrol Crowley at the local state grammar at Rayleigh. When he began to think it childish, he stopped drawing cars and enjoyed television satire programmes like *The Frost Report*. The cartoonist Giles was added to his list of favourites as he grew up, and by the fifth form he was reading magazines like *Private Eye*, largely for the strips illustrated by Willy Rushton and Barry Fantoni.

Fig 4. Black Painting, 1972.
Oil on canvas, 177 x 127 cm.
Destroyed.

Memory has its place in accounting for why Crowley's paintings have taken the appearances they have. Just as Charles Dickens' experience of childhood had an impact on his literary career, with shades of the young Dickens in many of his most beloved characters, including David Copperfield, Oliver Twist and Pip in *Great Expectations*, the convulsive, oppressive imagery of *The Clampdown* (1982) (plate 13) and of Crowley's general output of paintings until the 1990s has been nourished by an amalgam of personal memorabilia, direct experience and acquired graphic or cinematic clichés. One recollection dates back to when he was aged four and he watched as his teddy bear was torn apart by dogs.

Aggression of the type where fur flies and punches rain down proliferates throughout animation, with victim and assailant recovering to fight another day. Cartoons combine the dumb and the eloquent, the fun-loving and the sinister in interrupted narratives where the unlikely becomes commonplace (jumping ravines with one bound or death-defying feats are routine). Crowley's affinity with the cartoon-like image has intensified from its origins in the youthful consumer of film, television and British comics. The medium helped form his idea of an artist and became the nexus that brought together a spectrum of attitudes about what risks and content are needed to take painting forward. At school he never met a living artist, and he possessed no conception of the position an artist occupied. 'I've seen life without art,' he has said, 'and I found it a profoundly dark and scary place.' Preparing for entrance into foundation studies, by which time he was aware of Lichtenstein and Pop Art, he expected to specialise in graphic media.

The pub sign resembles a memento of these years. With its simple areas of flat colour carrying the action of the figure placed against it, the image recalls classic creations such as *Gerald McBoing Boing*, the animated story of a little boy who communicates through sound effects instead of the spoken word. The artwork of the award-winning short film of 1951 (that transferred to television in 1956) was remarkable for

breaking away from the strict realism and 'good taste' that Disney had perfected. Lifelike representations were supplanted by caricatures and backgrounds that implied a setting by using a non-perspectival, all-over colour ground from the lighter end of the spectrum and just off key, and only indicative outlined details of furniture or buildings. Thus realism could be subverted but, through the display of elements of the present-day and familiar, no break was needed with what the audience knew. However outlandish the story or the actions of characters, the image retained its credibility.

Crowley's assessment of cartoon-derived imagery was enriched at different stages of his life by looking aesthetically and critically at the work of Ed Roth (1932-2001), creator of *Rat Fink* and of Hot Rod culture; Hanna-Barbera studio (*Huckleberry Hound*, *The Flintstones*, *Top Cat*); and especially George Herriman (1880-1944), the American cartoonist best known for his comic strip, *Krazy Kat*. The appeal of the leading exponents of cartoon imagery remained among his maturing ideas as he negotiated the problematic landscape that existed for painting and its practitioners in Britain and America when Conceptualism held the upper hand. Its high point in art education occurred as Crowley progressed from foundation to the undergraduate course at St Martin's School of Art in 1969.

∎

What projected Crowley towards painting was the near blanket adherence to Conceptualism by his art school peers in the late 1960s.[7] Conceptualism saw a role for art which was different from that embodied in traditional media like 'easel' painting. Its influence was sufficiently extensive for the posture of progressive painters to be informed by it while at the same time resisting its essential literalness. Among the school's authorities, the position of painting had waned in the presiding pedagogy, the most prominent part of which was now reflected in the sculpture department and its two 'groups'.

The 'A' group was directed by Peter Kardia. It employed behaviourist methods and in 1969 the procedural experiment of 'The Locked Room' was instigated. Remembered as 'one of the most radical episodes in British art education', the course encouraged students to adopt a critical, even sceptical attitude towards the traditional idea of making sculpture.[8] The second group was led along formalist, perception-based constructivist lines by Anthony Caro.

In this milieu Crowley's decision to choose painting was influenced by wishing to avoid the emerging orthodoxy, a kind of institutionalised revolution with, as it seemed to him, little time for history. This oppositional trait reacted to the critical consensus that, he felt, demonised traditional practices; in his foundation year, he had heard painting pronounced as irrelevant. By contrast, his desire to make paintings followed what he has described as the revelation to him of the processes to which he was introduced to him in that first year. The medium had been 'demystified' and from that point he grew into a close relationship with painting's possibilities and particularities.

To decide which paintings to make Crowley embarked on a form of discourse with the institutional environment around him. A natural inclination to question orthodoxies and to insouciance about the approval of others helped to open the way towards subject matter that interrogated academic practice that was not, in Crowley's opinion, immune from the corporatism that characterised British politics and economics in the late 1960s and into the 1970s. Expressed through his research was personal unease with the tendency among younger artists to seek their seniors' approval.

Crowley recalls the teaching staff as supportive. Among them were Gillian Ayres and Henry Mundy in a department headed by Frederick Gore, and within the requirements of the course, they were happy for him to follow his own initiatives. He felt a rapport with the dynamic presence in the school of Michael Williams and, most of all, of Raymond Durgnat, the film critic who taught at St Martin's in the 1960s.[9] The importance of film in Crowley's outlook cannot be overestimated and Durgnat's humanistic view, which

regarded as the most important those films that enabled a receptive spectator to live more fully through challenging experiences, balanced what Crowley criticised as detached and impersonal in Conceptualism. In his writings and lectures, Durgnat also helped focus, through reference to cinema, Crowley's pursuit of subject matter on imagery, the rejection of which characterised Conceptual art.

In the maelstrom of 1969, the curricular concentration on the New York School struck Crowley as limiting. It grated with his political instincts which were hostile to America's policy in South-east Asia, one aspect of his activism that showed itself outside the studio as a student leader. He was involved with the National Union of Students as vice-president at St Martin's and with the left-wing London Art Schools Alliance where he contributed to intense debates but was put off by the aggression with which others commandeered discussions on current events. (He has continued to support broadly left-wing causes, treating art and the social world as distinct and equal entities that converge on the context that supplies levels of meaning to his imagery and how it has been created.)

At the time these affiliations also drew him towards counter-cultural experiments in the arts. At one extreme was the music and philosophy of Cornelius Cardew (1939-81). Cardew's compositions used graphic scores rather than traditional sheet music that allowed anyone to join in, although his performing ensemble, the Scratch Orchestra, was a disciplined group. There was an emphasis on improvisation and the serialist languages pioneered by Pierre Boulez and Karlheinz Stockhausen. At the other extreme was Dan Van Vliet, better known by his pseudonym of Captain Beefheart. Van Vliet's album, *Trout Mask Replica* (1969), exerted its influence on Crowley: its wide variety of genres (including blues rock, avant-garde, psychodelic rock and what can now be regarded as 'protopunk') articulated a desire in the artist for options beyond the conventional choices.[10]

The most intellectually formative period came during his postgraduate years in the Royal College of Art's painting department. On arrival at the college in 1972 his painting can best be described as being in 'mid-discourse', uneasily preoccupied with post-painterly abstraction and groping for alternative vocabularies to those that were officially sanctioned. An example, *Black Painting* (1972) (fig. 4), shows Crowley consciously deepening the historical focus beyond the pure-painting idea with homogenous colour values to question the precepts of Conceptualism.

The painting pitches colour-field restraint against the calligraphic, all-over disposition of indexical marks or shapes and, with hindsight, the seeds of appropriation are detectable in its surface. The quote seems to be to Ad Reinhardt's 'abstract impressionist' canvases of 1949-50 before all the components of his paintings were systematically refined. Painted in oil on a medium-sized canvas, *Black Painting* is large but not monumental so that it neither overpowers nor is overpowered. The vertical orientation and scale of the canvas establish the format on which Crowley continued mostly to work until the late 1990s when, pursuing a proposition of the modern landscape genre, he took up smaller horizontal formats.

The handwriting-like marks in this painting deliberately play with several ideas, one of which is communication. Awareness of the scientific study of linguistics became quite widespread in the artists of Crowley's generation. Among sculpture students in the 'A' group at St Martin's, certain texts of general philosophy and linguistic theory circulated with official encouragement, and took their place to a lesser or greater degree in the ideas with which all students were bombarded. As someone alert to the thoughts and intellectual fashions making their rounds of his contemporaries, Crowley was affected by the climate of discourse generated by these propositions. He naturally assessed them for relevance to what he was doing (or trying not to do) and it is likely that he addressed them more systematically than many of his peers. A strong impression was left on him by A. J. Ayer's combative *Language, Truth and Logic* (first published in 1936) because its affirmation of the empiricist tradition placed significance on verifiable objectivity. A fellow student who was reading widely about linguistics was Richard Deacon; at St Martin's and subsequently his

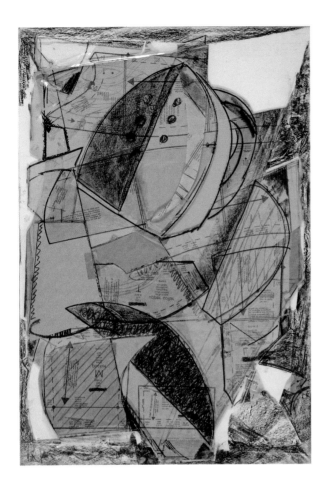

Fig. 5.
Untitled, 1972.
Collage on card, 81 × 55 cm.
The artist.

familiarity with Michel Foucault and other writers helped him to reconcile the object, sculptural and real, with experience of the external world.

As *Black Painting* indicates, Crowley was in pursuit of terminology with which to convey the beliefs that were coming together about the nature and function of painting. He began to pose the question to himself in the early 1970s about the identity of painting after Conceptualism. Never abandoning the idea of progress (despite signs around him of its collapse into stylistic 'anything goes') has required him to absorb the lessons of the 1960s. At the RCA he started to quiz the assumptions behind art's borrowings, a point reached when the route to encompassing his ambitions in painting drew him to the example, and pictorial language, of Fernand Léger (1881-1955). Crowley has not ceased to address that question and his answers have been contingent on the next possibility, a way of thinking that has justified the 'stylistic promiscuity' that has characterised his output. The appearance of his canvases has been as relevant to his purpose, and not more so, as the secondary meaning that every phase of his career has carried and which connects directly and eloquently with his on-going discourse.

As an institution, the RCA was more sympathetic to painting than St Martin's. Whereas Crowley's argument with his undergraduate course was its denial of the medium in the cause of progress, with his move to Exhibition Road (where the painting department was based) he encountered with difficulty what he perceived as the RCA's failure to move on from polishing the laurels of its heyday in the 1950s.[11] As at St Martin's the advances Crowley made materialised more through intellectual rapport with his tutors than through their teaching. And these advances during three years at the college had fundamental, long-lasting consequences for the direction of his work and the position it reached in the shifting priorities of the British art world in the following decade. What emerged, tentatively at first in a spate of 'neo-Cubist' collages

(fig. 5), was an attitude in his painting that affirmed reality in objects; revalidated figuration but not through direct representation; that related formalism to the world of social experience through strong imagery; and recognised colour as a material indispensable to life.[12]

Two tutors who were art historians as well as painters provided the catalyst. John Golding had joined the painting department in 1971 and in the following year Peter de Francia became professor of painting. Both men were cosmopolitan by birth (each had a mixed family background, together involving British and Mexican, French and Italian antecedents) and by conviction. In 1953 Golding had concluded that 'I could never fully appreciate much subsequent modern art... until I had come to terms with Cubism.'[13] This specialisation informed his teaching while de Francia's formation as an artist had necessitated his own spirited dialogue with artists representing a specific strain in art history. His responses to Beckmann, Picasso, Léger, Goya and Daumier are apparent still in his drawings. These tutors' inclinations (and how de Francia, specifically, expounded his enthusiasms) suited Crowley, and although in the 1970s their reference to these historical figures was often misunderstood, it granted artistic permission and confidence to their student to pursue a similar intrinsicality with history.

Léger was not much referred to in the 1960s, but his posthumous fortunes were changing: Golding and de Francia were instrumental in directing fresh attention to his work. De Francia's book about *La Grande Parade* was published in 1969 and in 1970, Golding and Christopher Green organised the groundbreaking exhibition which Crowley saw, *Léger and Purist Paris*, at the Tate Gallery. A major retrospective opened in Paris late in 1971 and in 1973 Léger's writings were published in an English translation by Thames and Hudson. These events, underpinned by Golding's definitive study of Cubism first published in 1957 (and issued for the first time as a paperback in 1971), provided the basis for a revival.

That it was timely for a number of artists working in a context akin to Crowley's is acknowledged by the painter and writer, Timothy Hyman. Four years Crowley's senior and a student at the Slade from the mid-1960s, Hyman wrote in 1977: 'I believe many artists are beginning to recognise how impoverished the context of much current painting is. What is admirable about Léger is partly his readiness to enter into the intellectual development of his time, to harness his creativity to societal as well as personal concerns, and so to lead the artist out of his isolation... Léger clarified in his writing, and went far in his painting towards solving, the fundamental problems of the painter today.[14]

The value of Léger's example to Crowley lay partly in painting. He absorbed a broad sweep across Léger's production, from the abstracted, Cubist images before the first world war to the purist paintings of 1918-25 that introduced, as well as a new materiality, a 'great subject' expressed in contemporary terms. Crowley's own misgivings about the mystification that had overtaken the idiom were confirmed by Léger's reference to abstraction as a journey into the void which had released the French artist's certainty about realism. This development coincided with the new intelligence about complex configurations of meaning, like 'being' and 'otherness', surfacing in the work of Deacon and Bill Woodrow. A single image could consist of multiple layers of significance, permitting the artist intentionally to communicate notions of making, nature and culture without imagery being shaped slavishly in form recognisable from the external world. These reflections cleared the way for their interpretation of 'new object' sculpture from 1980.

Just as Deacon's ideas echoed the immediate context of sculpture Crowley, in offering a counterpart in painting, was responding to the current condition of his medium.[15] In Léger he observed a dialogue in ever-growing volume with modern reality through shaping objects directly that was increasingly liberating. As de Francia pointed out, 'Léger's art is cyclic. It avoids the violent cleavages of style and the "conversions" with which the art of the twentieth century is strewn.'[16] The ramifications of Crowley's immersion in Léger and in artists like Stuart Davis to whom Léger had given licence materialised over an extended period. For another equally significant part of Léger's value was the non-prescriptive character of his precepts about painting.

Into these flowed his moral and social perceptions of painting's function built on bold imagery which communicated with its audience. Impressed by the power of cinema to project such imagery to a wide public, Léger attempted to broker a 'contract' with architecture to fulfil the role of the painter in society.

In the mid-1970s, therefore, Léger pointed a way out of the obscurity and superfluity into which Crowley and other artists felt painting had fallen. That the Frenchman was not easily confined within a prevailing style added to his value; as Golding had pointed out: 'No other major twentieth-century artist was to react to, and to reflect, such a wide range of artistic currents and movements. Fauvism, Cubism, Futurism, Purism, Neo-Plasticism, Surrealism, Neo-Classicism, Social Realism, his art experienced them all. And yet he was to remain supremely independent as an artistic personality.'[17] Nonetheless, Léger's assumption of figuration to propose the ideal of harmony between worker, industry and nature was too great a step to follow immediately. Its logical development out of the formalist earlier canvases, however, laid an intellectual path on which Crowley had set out by the time he left the RCA in 1975, to an extent that he may not then have realised.

Two more stimuli combined to enhance Crowley's positiveness in the desirability of reforming the function of art in society that Léger's example put heart into. The first was travel to France and Italy, often in the company of David Wiseman and like-minded contemporaries. Conversations with Michael Major, who shared his unease with the authoritarian consensus around Conceptualism and who had already begun to cite Cubist references in his paintings, helped in acquiring the germ of ideas that he could take forward in a personal manner. They offered peer context to his talks with de Francia, Golding and another tutor, Ronnie Rees, who had taught Major when he was studying in Birmingham.[18] It was also in this way that he realised that art history was central to his growth as a painter. His 'functional curiosity' was directing him towards the viability of being a painter and away from the delimiting legacy of growing up with no social privileges in dormitory towns.

The second was the emergence of punk rock music in London clubs in the year after he graduated. This coincidence and the music's claim to be radical (the antithesis of the cultural ideas associated with 1968) captured his attention. Its assault on previous counter-cultural developments that had been swept into the commercial mainstream was fresh and compelling; that it found expression in fashion and graphics with a popular following was even more so. Crowley admired the artwork created by Jamie Reid especially, an affiliate of 1960s Situationism, that packaged recordings sold at venues, in shops and on streets, viewing it as analogous with Léger's use of the wall and poster.

What made these convergent ideas admissible, however, was Crowley's conviction from the time he was at the RCA that neither originality nor integrity, in the terms that these phrases were understood within art at that time, was a prerequisite to a career as a painter. In the years since, Crowley has never revised his view that synthesis rather than originality is the most plausible way to advance painting. Many different existing strains of imagery or practice are drawn together by the individual and the result is, at best, a hybrid. This belief is the foundation of Crowley's 'project'. Embarked upon as a postgraduate, he has sustained its central premise to the present moment. And from its start at the height of Conceptualism and Minimalism, the project has been resolute that formalism is only interesting by virtue of reflection and that, of itself, it cannot maintain interest and purpose.

The practice of borrowing through references (upon which the concept of reclamation was built) took root at the RCA and queried originality on the grounds of historical impossibility. The view was formed by looking critically at the art of the recent past; as time has gone on Crowley has looked deeper into art history. An early instance is *Tug* (1975) (fig. 6), a composition animated by conscious references to the early, idealist modernism of Mondrian and the Cubist reliefs of Henri Laurens. Also apparent is the recognition of precedent in the application of collage and a certain loose-limbed restlessness about formal elements that

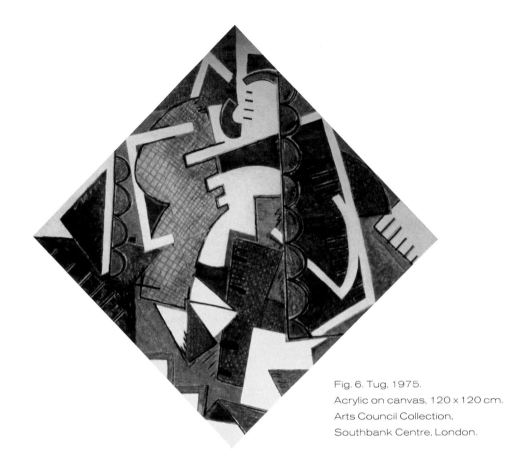

Fig. 6. Tug, 1975.
Acrylic on canvas, 120 x 120 cm.
Arts Council Collection,
Southbank Centre, London.

seems to derive from Léger's *Contrastes des formes* (1913-14 onwards). As convincing a source is George Herriman's *Krazy Kat*, *Gerald McBoing Boing* and his stable-mate, *Mr Magoo*.

The diamond format of the canvas (a square stretcher hung on its point), however, announces a formal dynamism particular to Crowley. It tilts against the conventions of the time by denying or, at least, modifying the rectangle. *Tug* openly flouts the rules. Within an art world that he perceived as sclerotic in its adherence to once-radical developments that had become institutionalised, he introduced a punk aesthetic. This blast of the new counter-culture was a correlation in fine art with what The Clash would shortly become in music: politicised, experimental and rebellious, and underpinned by practical intelligence within the artform.[19]

The interweaving facets in *Tug*, and in the paintings such as *Canvey* (1976) (plate 1) that he was making until 1979 in his London studio in Baldwin's Gardens, off the Gray's Inn Road (fig. 8), pursued a direction that lacked the approval of the mainstream. They relate to gestural painting, the discipline of drawing and to the spatial organisation of low relief. The centring of principal elements echoes Léger but Crowley departs from that influence with the insertion of illusory shadows within the picture space. A detail with natural and comic implications, it had no part in the high modernist originals. Working with collage and bright colours in acrylic paint Crowley invested these paintings with a superficial rawness, what William Feaver described as 'Elastoplast pink and brightest evergreen deposited on the picture surface like painterly sandwich spread.'[20] Indeed, Crowley was applying paint with a pointing trowel to create what he has described as a 'wilfully ham-fisted and robust' painting that tests the boundaries with its aspirations to the 'vulgar', 'low' and vernacular.[21]

What Crowley assembled would, in the postmodern era, be termed 'appropriation'. For by the mid-1980s, it was established as a theme in art, carried out by artists such as the Americans Sherrie Levine and Elaine Sturtevant, and legitimised the quotation of other work to create new work, especially when that new work accompanied or precipitated a critique of mass culture's usurpation of imagery. As a challenge

to the idea of originality, power and consumerism Levine might appear an ally of Crowley's were it not for the British painter's critical distinction between commenting on the vernacular and actually living it. In that discussion, Crowley would place Levine, and earlier appropriations of past art or the demotic such as those by Warhol or Lichtenstein, in the former category as observers of the everyday with a quasi-intellectual mission.

By contrast, Crowley's concern has been to 'live in the culture'. He alludes to high and low culture as the lingua franca of daily exchanges between reasonably informed protagonists. The objective of his project has been to integrate painting into the lexicon of those everyday exchanges. That vernacular culture has multiplied and fragmented rapidly since the late 1960s, assisted by the daunting growth of the means of dissemination, is a benefit that, in his view, art has been slow to grasp.

On the other hand, Crowley will fuse in his work (by the lack of overt distinction) *Krazy Kat* and a Dutch seventeenth-century landscape etching in a manner comparable with the ebb and flow of language in communication. An equivalent exists in grammatically-correct Received English intermingled unselfconsciously with common slang and the sentence constructions and residual idiosyncrasies of geographical and social origins in the daily conduct of working life for the majority of English people.

■

With the transition from the non-figurative images of the 1970s to the paintings with which he entered the next decade, and which brought him critical acclaim, Crowley ventured more into the vernacular expression of pictorial language.[22] The ambitions of *The Living Room* (1983) (plate 15) did not lie with the heroic, romantic connotations explicit in the 'new image' painting of contemporaries like Christopher Le Brun or even the direction being followed by Alan Miller around 1982, but with humdrum activities around the home, such as grating cheese, ironing and darning and watching television.

The shift towards figuration appeared dramatic to observers. For the artist, this first demonstration of his serial 'stylistic infidelity' was rational and necessary. 'By about 1979,' he recalled to the writer Robert Ayers four years later, 'I began to suspect that those paintings lacked a great deal. They were becoming less and less demanding. The arbitrariness of their formal design was becoming increasingly obvious and less and less engaging.'[23] The critic, John Roberts, concurred. Crowley's first one-man exhibition, at the AIR Gallery in London in February-March 1982, showed the new interiors alongside landscapes and scenes from nature, artificial in colour and filling the picture plane so that they resembled interiors. One of the largest canvases featured a bird's nest viewed from above. Inside are three huge eggs which the structure of twigs can just about contain, each one a different primary colour as if grotesquely modified genetically by pesticides. In his review, Roberts wrote that 'Crowley's switch to stylised figuration and narrative represents a far more imaginative and confident treatment of sources... [the paintings'] piquancy marks their romanticism as highly personal [and] reveal... Crowley's theatrical, in some cases almost Gothic, sensibility... There is nothing throwaway about the work; Crowley is not posturing.'[24]

Realism was tightening its grip on his artistic personality and it no longer seemed satisfactory to deny figuration. He sought to avert the pitfall in modernism that almost obliges the artist to repeat a metaphor once it is successfully formulated. And he wanted to address an audience still unconvinced by Minimalism's reductiveness. As his historical references lengthened, Crowley saw as a shortcoming the 'declamatory' quality of his work at the end of the 1970s. He became interested in how the familiar in everyday life was made unfamiliar in art. Rejecting Pop Art as the fully-fledged style recruited into the academic cannon it had set out to become, Crowley filtered ideas borrowed from eighteenth-century masters like Chardin through the screen of recent figurative idioms that were perceived as democratic in their distribution. The centrepiece of *Table Manners IV* (1985) (fig. 7) is a meat pie set on a table in a room where

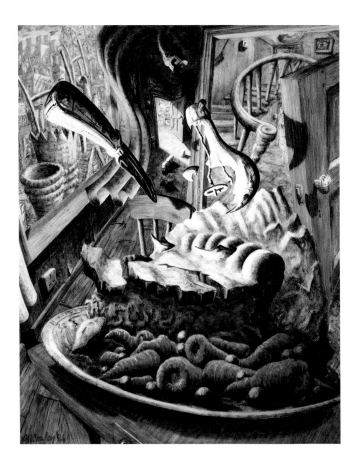

Fig. 7.
Table Manners IV, 1985.
Oil on canvas, 209 x 167 cm.

an open door causes a draught that sets the curtains billowing. That description is less than half the 'story'; the viewer who grasps that (and Crowley hopes most will as 'nobody would paint about cheesegraters, that would be inconceivably slight') then tackles the metaphors in cutlery and pies to advance the significance of the image.[25]

Thus, his 'new image' subverted realism as quickly as it was imported. As airborne metallic knives mimic missiles in flight over the meat, vegetables and other natural produce of the land that are the stuff of life, so the image seizes on the threatening state of the world, *circa* 1985. His dystopic 'fly-on-the-wall' treatments were also faintly suggestive of television documentaries which anticipated 'reality TV', such as *The Family* (1974) made by the BBC and subsequently richly parodied. Crowley's paintings projected the possibility to the viewer that the artist had reached in and grabbed a piece of his home.[26] Sometimes with glee and sometimes with sorrow, home was portrayed as a place in flux and improvisation.[27]

*So and Sew* (1980) is the transitional piece. Formalist imagery had already loosened out of the angular, geometric shapes of *Head 2* (1977) (plate 6) into the plumper, inflated vermiforms and linear spirals of *Phlogiston (3)* (1979) (plate 8). The shapes in this mini-series of canvases become both literal objects and a metaphorical substitute for the person, a dichotomy that Deacon was investigating in his sculpture of the same time. Imbedded in the title may have been a clue to this evolving status of the image, phlogiston being an imaginary element believed in the eighteenth century to separate from every combustible body in burning. These newly organic, naturalistic compositions nonetheless kept high-keyed, confectionery acrylic colours which *Artforum* described as an 'acrylic-gel parody of fat oil paint reminiscent of varnished ice cream'.[28]

*So and Sew* revolves, figuratively and visually, around the domestic activity of sewing. Vestiges of hands, a needle attached to a cable-thick arabesque of thread, an eye (or is it part of the sewing machine?) are derived from the rounded and vaguely modelled shapes of the previous year. The tangle of limbs and

needlework implements has moved away into a room, an architectural area offering angles and high viewpoints. Having now to consider the role of subject matter, Léger was again a guide: his synthetic figuration in the *La Grande Parade* (1954) captured the energy of modern life and popular entertainment.

Crowley parts company with Léger's vision of social unity by immersing the scene in discord and coercion. Frustration is sensed in the awkward movement in and around the illusory space and in the curious, formal half-way house that objects occupy between reality and illusion. The act of sewing is synonymous with gathering and joining, with constructive labour, while *So and Sew* implies order sundered by disharmony. The image ambivalently straddles linguistic homonyms between comic cack-handedness with needle and thread and the vernacular phrase 'so-and-so' that replaces a descriptive oath used to dismiss another person in exasperation.

What emerges successfully, however, is an atmosphere bordering on fantasy, as when *Tom and Jerry* are shown spinning in a ball of fur and features as the cartoon pair clash fruitlessly in the latest bout in their never-ending competition to outwit each other. Feaver greeted the image when it was selected for the twelfth *John Moores Liverpool Exhibition* in 1980, as 'mock expressive' containing 'more than a hint of snackbar plastics, such as tomato-shaped ketchup containers, and of Van Der Beek, the original Noddy illustrator'.[29] Later the same critic wrote that this painting showed details 'snaking through a range of influences: Patrick Caulfield, Stuart Davis, Gris, Picabia, Léger. The excitement clearly lay in creating illusion. Instead of working on disassociative grounds Crowley found himself opening doors into pictorial space.'[30]

In 1981 Feaver wrote that 'Crowley is currently working in a pneumatic kind of Disney-Picasso idiom, popular at the moment as an alternative to the preciosity of Marc Camille Chaimowicz, for example, with his cameo effects, or the sheer cool of Michael Craig-Martin.'[31] In Crowley's formulation, however, of a narrative art that issued a challenge to the viewer on several fronts, a more accurate comparison was with a 'Léger-Herriman idiom' or with *Gasoline Alley*, the gentle, classic comic strip about nature and daydreaming that has appeared in American newspapers since 1918 and in which *Krazy Kat* first appeared as a predella-like component. In this way his affection for cartoons was remodelled into a loose structure within which he could experiment with content as well as image. It offered a type of shared territory with the audience, the constituency he kept and with whom his paintings must communicate.

Cartoons provided signs towards broader meanings. Within the precincts of the world of animated imagery objects defied reason and gravity; they could assume anthropomorphic personalities; light and shadows conveyed particular moods and expectations; and colour was not present to render the illusion of reality but, in a Kandinsky sort of way, to inject feeling and emotion. 'At least in the context of art,' Richard Wollheim wrote, 'intention must be taken to include desires, beliefs, emotions, commitments, wishes.' The viewer will infer the intention from the way the painting looks, Wollheim went on, which 'presupposes a universal human nature in which artist and audience share'.[32] The audience had been made familiar with these ground rules by cinema, television and the printed page; Crowley's appropriation was an acknowledgement of the influence of the 'readymade' in coaxing the spectator into confidence to cross the threshold in art.

In *The Living Room* (plate 15) Crowley attracts the viewer with drawing of a type not associated with fine art: the illusion of reality about the domestic accoutrements of television, electric lamp under its tasselled shade, armchair and its supine occupant quickly converts into a realisation of the artifice behind the animation of many of the same details. The television plug rears forward on its cable like a venomous snake prepared to strike out at the onlooker; curtains billow ominously; and other melodramatic effects, familiar from the fictional world of the screen, spell out a mood of eerie disquiet pregnant with the possibility of violence. A sinister yellow light glows behind the television set in contrast with the chill blue aura that showers out of the front of it. Many of these devices are known from Hammer horror films or the upside-down world of *Tom and Jerry* where 'aids to modern living fail to guarantee a totally secure haven'.[33] They

seemed to imply that fantasy was the natural idiom for humour and also for dealing with the artist's and viewer's existence in the contemporary world.[34]

Once encouraged across the threshold, the viewer is offered a choice by Crowley, thus signalling the departure these paintings make from the conventions of the still-life genre. That person can indulge the narrative potential or couple it with reflection on the implications in that image for a spectrum of contexts between the cultural and the political. A third way exists: it regards these images primarily as a critique on the nature of the idiom at the time of its creation, a position that provokes a debate. That is an outcome that Crowley has long encouraged as one function of painting and of prolonged looking, itself an act on the verge of subversion. The artist endorses the experience of Richard Wollheim: '... I came to recognise that it often took the first hour or so in front of a painting for stray associations or motivated misperceptions to settle down, and it was only then, with the same amount of time or more to spend looking at it, that the picture could be relied upon to disclose itself as it was. I noticed that I became an object of suspicion to passers-by, and so did the picture that I was looking at.'

Behind the surface gesticulations of these paintings, Crowley was working on his answers to serious questions. One concerned the identity of the painter after Conceptual art. His painting *3B* (1982) (plate 12) masked with a veneer of cartoonish humour a paining uncertainty. The artist in the image uses his own nose as a fat 3B pencil. The glare of artificial light and encroaching shadows concentrate the scene into a shallow alcove of space so visually constrained that the viewer's chest tightens in apprehension of the central character's mounting panic. 'Crowley... has the zest of the true caricaturist, never content to let things be as they are... Self, self-image, mirror reflection of self and all three together – himself in triplicate,' William Feaver acutely observed, 'amount to an agile and suggestive study of what it is to take oneself not too seriously.'[36]

At the same time, from scrutinising the litter of scrunched up balls of paper and the shaft of his pencil, an angry red because pencils are coloured red but also reddening like irritated or flushed skin, the sensation arises of gathering frustration and infirmity of purpose. The portrait the artist delineates on the latest sheet to be worked resembles the man reflected in the mirror he holds aloft. But it also has the likeness of Barney Rubble, the engaging 'straight dope' character who played second fiddle to Fred, his eager neighbour in the popular Hanna Barbera animated television series, *The Flinstones*. Quite what the viewer is expected to conclude, however, is not spelled out. Instead, the suspension of any 'approved' meaning issues its own message, namely that by paying attention to it, the image gives out more than either casual examination or preconceived assumptions prepare the spectator for.

∎

This quality of alternative or parallel interpretations is attached to another question Crowley asks himself in these 'anthropomorphic' paintings. The craft of painting is given prominence in the visual facts of the surface. He resumed working with oil paint in 1980 and has described the years that followed as his self-education in its use. On his return from a visit to Italy in March 1981, images began to take shape in an intensely methodical manner.

Over an outline drawing in charcoal, the composition of *3B* was worked up in white relief on a white ground into a monochrome foundation. This product of many hours of laborious construction has the passing resemblance to a relief map of the seabed. Crowley augments this foundation by using Payne's Grey, a moderately coarse blue-grey made from crimson, blue and black, often mixed with white oil paint, to convey volume and physical presence. Then thin oil glazes of colour are added, the next wet upon the last once it has dried. The number of colours is often limited; an overall matrix of red, yellow and green has grown up and continues to the present.

Fig. 8. Artist's studio, Baldwin's Gardens, London, c.1979.

Fig. 9. Artist's studio during residency, Museum of Modern Art, Oxford, 1983.

The tonal range, however, is extensive and colour is not confined within the outlines of objects to provide local description but spreads to envelop an area. While this practice dilutes illusion, its validity derives from how colour is experienced in the phenomena of daily life. The white under-painting suffuses the layers above with the impression of luminousness from within the image. By contrast, and contrasts are integral with Crowley's pictorial vision, areas of Payne's Grey are deepened by the glazes into shadows. This way of working, an adaptation of early Renaissance techniques that Rubens and other Baroque painters later adopted, complements well Crowley's use of charcoal to make drawings. Elements are extracted from drawings to form the basis of paintings. Crowley has described himself as 'a contour painter' because his process also makes possible a distinctive impression of compressed space that is equally Cubist and Mannerist in inspiration. Volumes seem to interpenetrate yet at the same time occupy negligible depth on the painted surface.[37]

This degree of technical effort was maintained for almost 20 years and appeared to deviate from the general direction that painters were taking. His 'delight in paint that is at once sensual and restrained', as Marco Livingstone has described it, provided its own justification, elucidating the almost forgotten beauty of the material.[38] Crowley shared the unease of some of his peers at the trend in the late 1970s towards gestural painterliness in revived expressionism (if not pseudo-expressionism from the start, a simulation of the real thing) as the vehicle for the wide-reaching acceptance of representational styles in painting. Spreading within institutions and studios in Europe and North America, it risked charges that postmodernism was devoid of history and that its products lacked substance, having been assembled for superficial visual appeal.

Moreover, the reclamation of the grisaille technique deviated from expectations associated with cartoon-like figuration. The artist's adoption of a rigorous manner was not a ploy to attract attention to his work but an element that blended naturally with his overall project. It fuelled the bifocation in the route the viewer was presented with after the initial encounter with the image to signal participation in the discourse about painting. Method simultaneously displays and elicits interest, setting up the frame of mind that can help draw out other propositions in the discourse that Crowley is inviting the onlooker to reflect on and take forward. Finally, as Feaver pointed out about Crowley's approach in 1988, 'he proceeds methodically, knowing that to be expressive in painting means not being slapdash'.[39]

The disquiet unleashed by details in objects and by disturbing elevated angles of vision like those in *Spider with Mushroom Soup* (1982) (plate 14) also disclose the opportunity to examine meanings beyond the obvious. As Livingstone pointed out in 1984, 'One of the most impressive features of Crowley's current paintings is their potential for dealing with a wide range of issues and experiences through the manipulation

of familiar imagery, formal devices and pictorial conventions, without appearing to effect any transformation of the basic means or format adopted.'[40] In this painting, Crowley operates within the established genre of the still-life, while pushing its subversive modification to the point where the venerable category is overturned like a long undisturbed pot in the garden to reveal life teeming beneath it. It is as if Crowley sets the pots and pans of Chardin on edge among the troubling cowled figures of Philip Guston's later paintings in order to modify with critical acumen the existing cannon.

The synthetic nature of these paintings has been carried forward consistently to the present and assumes some historical knowledge that the spectator will contribute in an assumed compact. The bargain recognises the seriousness of the spectator's inquiry into the painter's intent to detect multifaceted layers of significance. The primary level, at which the image declares itself visually, remains available regardless of these historical references; the secondary level of broader interpretation, however, asks for a robust standard of attention and interest. The painting *Light Fiction* (1985) (plate 16), for instance, contains ingredients for a narrative that can be strung together by the scrutinising eye.

Reading from left to right in the way a line of text is absorbed (and, perhaps, back again as a line of more demanding text is reviewed to check details), prominent features are a mug, toothbrush and two light bulbs. Occupying the bottom and top edges of the foreground, they frame a chair and floorboards that direct attention towards a distant doorway that, in turn, helps to make sense of the angled panels that lean into the image from each side: a mirror on the left and a glazed window frame. These elements update the traditional format of still-life painting. In seventeenth-century Spain, Juan Sánchez Cotán observed vegetables from the market that epitomised subsistence in the contemporary home. By placing them on a shelf or suspended from a lintel, tonal gradations heightened spatial values and permitted vision to penetrate beyond realism to the possibility of secondary, unanticipated significance in the most familiar forms.

Crowley depicts items familiar in the daily existence of twentieth-century western culture. In the mid-1980s that culture was uneasy with itself. Employment was neither secure nor plentiful in Britain where politics had been polarised between left and right by the policies of the Thatcher government. Crowley had personal experience of the uncertainty that seemed to surround British society on several fronts, occasionally doing menial jobs to support his young family.[41] The arts experienced retrenchment in public patronage while in the City of London the first signs of economic boom for private enterprise were showing as a consequence of loosening regulation, increasing globalisation of equity markets and the quickening pace of technological innovation. Nonetheless, British society was convulsed by opposing views of a year-long national strike by miners, a dispute viewed by liberal and conservative commentators alike as symbolising the death throes of long-established manufacturing in an era that would be dominated by the provision of services and the financial industry.

The anxiety about disenfranchisement by an autocratic regime, whether domestic, industrial or political, is displaced in *The Clampdown* (plate 13) into surrogates at a carpentry bench. Painted in the euphoric atmosphere that followed victory in the Falklands War that emboldened Mrs Thatcher into further institutional reforms, the title originated with a song from 1979 by The Clash with a chilling warning about extremists taking advantage of social discord:

*Kick over the wall 'cause the government's to fall*
*How can you refuse it?*
*Let fury have the hour, anger can be power*
*D'you know that you can use it?*[42]

The image unfurls from its central motif, a piece of timber gripped by a vice and assailed by clamps and nails. A shark-toothed saw and the gaping maul of a pair of pliers wait in reserve as the searing light

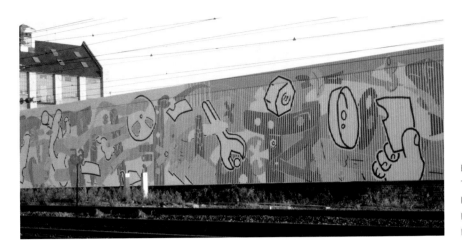

Fig. 10.
Ticket on the Move, 1981.
Pitt and Scott building,
King's Cross, London.
Demolished.

of a shaded lamp illuminates the distressed grain of the belaboured wood into a parody of *The Scream* (1893) by Edvard Munch. Meanwhile from the handle of the saw slips an alter-ego, a mask reminiscent of death or the muse of drama.

A more complex interpretation of events is brought home, metaphorically, in *Light Fiction*. One bulb radiates artificial light, while the other is captured in the aftermath of a catastrophic failure of some sort. That bulb has already shattered and shards of sharp glass are sent flying by the impact. Below, the tooth mug and brush appear to have been felled by this or another force and now languish beside an emesis of coagulated froth and the broken bodies of fractured toys missing a head or an arm. The source of mayhem may be the open window itself; it has let in this wind of change, a force of man more than of nature as the reflection in the window attests.

Hard to make out in this view of urban rooftops into which are flamboyantly impaled cross-barred television aerials like rugby goal posts, are objects that resemble bricks in flight and plumes of smoke (which bring to mind the popular English saying that there is no smoke without a fire raging somewhere). Above the chimney pots, a helicopter dips its whirring rotor blades into the thickening sky the better to survey the scene, whether for that day's 'flying-eye' traffic report or for the police to gather intelligence on disturbances the artist does not make clear. Although the formal qualities of line and colour sweep the scene into a semblance of coherence, the image is thrown back into the painting by a viewer unable to penetrate the grill of supposition to release fact. That process of searching and reflecting gives a sardonic edge to the word embedded in the foreground. Caught in relief on the handle of the toothbrush is the brand name 'Wisdom'. The word is brandished by the artist in the face of the onlooker and of current events like the chorus in a Greek play that chants counsel.

In his own self-deprecating manner, Crowley has described these troubling images as 'a crude attempt to paint life as I knew it'. Crowley's 'fiction' takes a common occurrence within the home and raises it to a level where it assumes almost theatrical grandeur. The scene acquires a presence that makes the curious viewer resist taking his leave of it too soon, either to complete his own fictional account or to push through the conceptual saloon-door of the picture plane to encounter the mental framework of questioning, rhetorical and otherwise, that Crowley occupies in his studio for the duration of each work. That lure to enquiry is made convincing by the coherence of the image: the washes of blue, yellow, green; the Baroque perspectives and dizzying angles; the way that no single object ever quite takes its full, realistic form all provide a foundation of physical solidity and thematic familiarity.

By 'setting the scene', the surface acts as a sort of base camp from which to scout the highlands where searching, structural ideas exist. In *Light Fiction*, the device of windows ajar over a domestic interior opens

Fig. 11.
The Birds, 1983.
Stove enamelled aluminium.
Outpatients' chest clinic,
Brompton Hospital, London.
No longer installed.

a reflection (literally and metaphorically) on causality, the before and after effects of a blowing light bulb, a span of time travelled in a single canvas. There is a legitimate comparison to be made with *The Studio* (1939) by Georges Braque and the series of large paintings of the same interior that this painter executed between 1946 and 1956. Crowley's interiors can be regarded as the artist's meditations on his works, both past and present, as well as his surroundings, both real and imagined.[43]

An atmosphere of menace emanates from objects as if frustration with chores was shared by or had been transferred from their human owners on to kitchen and bathroom paraphernalia. It pervades the stiflingly claustrophobic settings of the 'anthropomorphic' paintings and led one critic to wonder if Crowley was claiming to establish a new genre. That was not Crowley's intention, nor has it been since. But the prevalence of genre types has been an important vehicle in his project for painting. He was becoming aware of the need for subject matter in his paintings in the late 1970s when the Cubist-derived non-figurative mode seemed to him to have run its course. 'I felt I couldn't go on making formalistic pastiches,' he told a journalist. 'I didn't want to paint for eight people anymore, I was bored with that.'[44]

■

By 1981 his historical focus had deepened. The two-week visit to Italy in March that year gave him the chance of seeing work *in situ* that he had only encountered before transplanted into the environment of foreign museums. One appeal of paintings seen in Roman churches and Florentine palazzi, such as the late Renaissance and Mannerist decorations in the Uffizi and Pitti Palace, was their affront to the sensibilities of his day. They contained elements such as subject matter and techniques that by the late 1970s were either neglected within art's institutions or were considered in some sense unsatisfactory. Crowley applied that appeal to his own work, perceiving in it a challenge to the assumptions about painting that had hardened during that decade.

He also became aware of the structural value of genre. Genre is the hierarchy of subjects that became an essential criterion in interpreting painting by the eighteenth century although it was by then long-established among artists. The spur to its ascendancy, however, was the academicisation of fine art. In France the annual *Salons* provided its platform and it was confirmed in England with the foundation of the Royal Academy of Arts in 1768. The genres were graded in order of importance, with history painting and religious imagery the most exalted, followed by the portrait, genre painting, still-life and landscape. Watteau was a rare example of a painter who invented a genre, although short lived, known as the *fête galante*. The value to Crowley of

genre was three-fold: in its most aggressively policed form, it was an invention of the academy; for centuries the fine arts had adhered to the categories of genre, with artists subtly improvising variations within them; and it had fallen out of use by the avant-garde with the arrival of modernism. Genre was, therefore, an instrument ready for reclamation and to be 'turned on its head'.

In addition, Crowley used the genre headings as a channel of accessibility for the audience he wanted to attract. To import content into his imagery, he had turned to his own life and work experience. Still-life (including interiors) was his choice of genre because he had admitted to himself that he could not do portraits or figure subjects. The reason was partly technical and partly ideological. He has not regarded his few attempts at self-portraiture as successful paintings. One example is *Sensitive Skin* (1986) and although the image has the quality of a personal testament, Crowley's unease was mostly attached to the connection made explicit within it between his subject matter and his personal biography. As Livingstone perceptively observed, there is 'a link between the possessions littered around domestic rooms and the thoughts, fantasies and memories cluttering our minds', and Crowley has preferred to interpose distance between what he paints and details of his own life.[45] At the same time, Crowley observed that his audience's affective engagement with details was best tempered by a degree of 'taciturnity' in order not to smother access to those levels of interpretation that depended on an awareness of the painting's abstract qualities.

Domestic interiors, however, provided the environment with which his audience would be most familiar as a place of solace and shelter in the home with which security and personal taste are most associated. From 1980 his project concentrated on how to make art with ambition that was in conversation with the contemporary and did not denigrate the lessons of history. This was more than a packaging exercise; his intention was to pose 'big questions' about the scope art has to reflect on life and about its own objectivity. It influenced Crowley's adoption of genre as a framework for his activities as it had the potential to entertain as well as to interrogate. He was also aware of taking forward an attitude towards his audience that contradicted the views still held by many of his peers and by the art education establishment. He was attempting to parallel in visual art the contemporary relevance and radicalism that punk rock had returned to popular music, design and fashion.

Although the anthropomorphic images shown in solo and group exhibitions carried forward his project within the art world, more visible and permanent in reaching viewers beyond those institutions were Crowley's commissions in the public domain.[46] While the 3,600 square-foot mural *Ticket on the Move* (1981) (fig. 10) at the Pitt and Scott building near King's Cross in London became the first large-scale installation to be completed, his ideas about how art can simultaneously raise expectations of an on-going cultural discourse and retain its broadly-based audience had been worked out the year before.

In 1980 Crowley submitted a proposal for the decoration of the vaulted ceilings of the escalator shafts at Holborn station, 'one of the most desolate sights on the Underground... the size of five tennis courts'.[47] Among the busiest sections of London's commuter network (34 million passengers travelled through the station every year by the end of the 1970s), Holborn offered artists a remarkable and prestigious opportunity. The competition organised jointly by London Transport and the Arts Council of Great Britain made entrants 'free to suggest a visual treatment for this space and to propose any imagery felt appropriate... The object of the competition is... twofold. It aims first of all to result in the commission of a work for a specific site, perhaps the most challenging on the whole tube system. Secondly, it is hoped that competition will stimulate ideas that could be commissioned elsewhere on the Underground.'[48]

Crowley was then emerging from a self-imposed sabbatical from painting, a period of almost a year during which his transition from non-objective imagery gained rapid advance. Described by Richard Cork as 'a cornucopia of circus-like forms tumbling down the shafts', his submission had a clear debt to Léger who advocated mural decorations as the best route out of the social difficulties facing the modern painter.[49]

Crowley received one of five prizes of £1,000 each and an invitation to develop his ideas in liaison with the architect in charge of the station's renovation.[50] Short-listed artists had then 'to argue the practical application of their proposals', a requirement particularly suited to Crowley's talent for debate.[51]

The commission was awarded to Ron Haselden for a ceiling studded with lights activated by the movement of passengers triggering photo-electric cells. The scheme was eventually abandoned on financial grounds before it could be implemented and in succeeding years only the redecoration of public areas at Tottenham Court Road station by Eduardo Paolozzi (1986) approached it for scale. Yet the experience, for Crowley, contributed formatively to the direction his work took from that point. Most significantly, it taught the artist his sensitive understanding of context. It also placed the locus for strong imagery, and the intellectual interpretation of imagery, within the general sphere of architecture as existential space. The wall-based public commissions that he created between 1981 and 1984 are, therefore, integral to his development as a painter even when, as happened with the installation at Brompton Hospital, London (1984), its form deviates from the concerns present in his easel painting.

The Pitt and Scott commission resulted from a competition, administered by the Public Art Development Trust (PADT) and once more supported by the Arts Council of Great Britain, after the original idea of an illuminated sign on the 138 foot elevation of the removal and storage company's new north London warehouse was revised. Cork, who regularly used his position as resident art critic of the *Evening Standard* to write about new public art with the intention of encouraging its merits and raising the level of ambition behind it, welcomed the 'subtle ways Crowley has made his decoration quietly at one with its location… With stubbornly unfashionable optimism, it depicts the act of journeying as an occasion for delight' when it was inaugurated in autumn 1981.

The building was a simple, box-like structure faced with corrugated steel situated in the area behind King's Cross station, a neighbourhood of low-rental housing and occasional small, trendy late twentieth-century offices in a decaying industrial landscape of canal, gasworks and goods yards. On its western boundary the building overlooked the track heading north out of the terminus, presenting the artist who was commissioned with an audience that was broadly based and potentially on the scale of that at Holborn tube station, similarly mobile but, in this case, (mostly) seated. As it was this flank that would host the artwork, Crowley combined travel and motion into the context for his successful proposal. While McEwen contended that the resulting painting 'is not much connected with current paintings', the enfolding concept (of formal dynamism, figurative elements drawn with bold graphic, cartoon-like exaggeration and a vernacular flavour) complemented the transition through which his work on canvas was going.[53] What Crowley dropped, for reasons obvious to the context of the mural, was the dark, unsettling undertone of menace; travel on Britain's railways, some may have mischievously argued, already provided that.

*Ticket on the Move* imagined a journey from city to country through delineations and elisions of simple forms that mirrored evocative, everyday objects. Spanners, bolts and girders paid a large debt to Léger's own late decorative commissions, while reels for computer tape brought the city experience up to date. These outlines then gave way to trees and organic shapes like hills and gates, united by the same muscular, chunky and irregular style and all of it decipherable from the window of a 125 diesel service accelerating away from or slowing to enter the station.

Emulating Léger, Crowley used bold, poster-like contrasts of form and colour, with strong black outlines and extensive areas of flat, uniform primary colours against a light grey ground. The corrugation of the building itself provided repeated vertical accents (a kind of fluting) the length of the flat surface; painting along the raised ridge, Crowley ran the contrasting horizontal frieze of the image. Its humour counteracted any descent into the grandiose; the wall assumes the trusted familiarity of close-ups on a wide screen in a cinema and the strangeness of a track-side location. Seen at an angle, as the train approached and passed, the

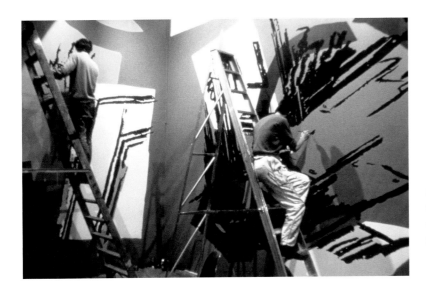

Fig. 12.
Simon Bill and David Austen working on Night Life, a painted installation with 'stage' lighting. Institute of Contemporary Arts, London, July-August 1984.

image gained, held and then lost focus with an effect reminiscent of a hoarding where slats rotate to change the advertisement on view.[54]

This textural variation was applied to three important commissions that followed. For the narrow curving staircase between the lower and first-floor galleries at the Institute of Contemporary Arts' Regency headquarters in The Mall, Crowley made *Performers* (1981), a temporary 'startling construction… fabricated out of colourful sheets of "Correx"; [it] turns the ascent into a bewilderment of jutting shapes' that echoed the King's Cross building but returned his practice momentarily to his non-figurative work.[55] Context dictated this choice; the space was too confined to make overt figuration useful, but it did allow him to import a physical sensation of disorientation that brought wider events from outside (the jangling city of noise and movement, and the general atmosphere of social unease) into a venue that regarded itself as non-establishment.

At the Brompton Hospital he made *The Birds* (1983) (fig. 11), an unproblematic visual scheme of silhouettes in bold primary colours enamelled on aluminium fastened to lateral rails above head height in the out-patients' department. The composition, which folded around pillars as well as extending along walls, provided an airy evocation of seabirds wheeling and swooping over cliff edges. Crowley had won the commission in a competition organised by the PADT and had consulted patients and staff while preparing his design.[56] This sensitivity to context and audience also embraced the practical requirements, such as cleaning, but by girdling the room, his installation had the effect of converting a place fragmented by activity, anxiety, potted plants, intrusive piping and diverse framed prints depicting open landscapes into a more coherent space.[57] The concept was adapted for *Four Seasons* (1983), the relief mural for the newly-built Chandler's Ford public library in Hampshire, that used seasonal leaf forms cut from coloured metal.

'Most of our public art is used as a Band Aid, to cover-up mistakes made by planners and architects, to brighten up parks and squares,' the art critic of the *Guardian*, Waldemar Januszczak, complained in a feature article in 1984. 'All this might bode well for society,' he went on after pointing out the value in enhanced productivity that many schemes returned, 'but does it bode well for the artist?'[58] There was an upsurge of public artistic activity in the early 1980s and it met with a mixed reception. Januszczak was not a lone voice in identifying the principal merit of these commissions as their practicality rather than their artistic importance. Crowley was both realistic and idealistic in his attitude to these opportunities. On the one hand, they provided the artist with an income with which to support his family. He had neither an established London art dealer representing him commercially nor regular teaching work, a staple for artists, until 1984. In that

Fig 13.
Study for Poetics of Space, 1986.
Compressed charcoal and
collage on paper, 30 x 21 cm.
The artist.

year Edward Totah presented Crowley's first exhibition in his gallery in Old Burlington Street in Mayfair and he became a visiting lecturer in painting at Goldsmiths' College in the University of London. Up until then, he had contributed frequently to courses at the RCA, at de Francia's invitation, and at the art schools at Leicester and Winchester since 1978.

On the other hand, he was inspired by a desire to dissolve the mysteries that he perceived had been thrown up around contemporary art in the 1970s. Abstraction never produced a truly public art and he generally welcomed the institutional backing from public and private sectors that these initiatives received as facilitating broader accountability by the arts to its consumers. Imbued with the aspirations contained in Léger's 'contract' between the architect and the painter and aware, too, that they had failed to materialise, he believed that a good standard of public decoration in the built environment, which had been arrived at through some degree of consultation, infiltrated into the civic demeanour of the public and their respect for their surroundings.

■

Complementing the textural variations in these schemes, some of which were contingent on the nature of the site (as at Pitt and Scott), were richer surfaces in paintings. They arose, firstly, from his adoption of oil paint and then, from 1981, in his gradual improvisation of the traditional technique of grisaille. This parallel development was, however, incidental and, in general, how Crowley carried out his public commissions was at best only loosely connected with the direction of his studio-based work. Nonetheless, the two were linked conceptually by his project for painting.

Although Januszczak had labelled Crowley in 1983 as 'one of the most important younger British

painters' the range of his activity in these years ensured his independence from the easy categorisation that the art world was prone automatically to apply to practitioners in the limelight.[59] Along with his interest in reclaiming the labour-intensive craft and the relevance of skill for art at the end of the twentieth century, his preoccupation with the notions in painting of space (both intellectual and illusionistic) and subject matter continued to challenge the consensus. The intensive technique of grisaille and tonal colour glazes began to reflect for Crowley his own thinking about the actual activity of painting. An artist who disputes the description of painting as an 'activity', being cognisant of the act of painting as a faculty (like the voice is to a barrister, or a pen to a writer - an instrument with which arguments or ideas are mooted), Crowley took up impasto partly in order to distance himself from the facility he disliked in neo-expressionism. The acquisition of skill then grew to represent a repository of knowledge that expanded, rather than diminished, the possibilities in interpreting an image. These emerging ideas, as well as being at an extreme far removed from mainstream contemporary painting, seemed to give presence in painting to the process of intentionality. The spur to this realisation was his search for fresh philosophical counterparts.

In Gaston Bachelard's book, *The Poetics of Space* (first published in 1957 and in English translation in 1964), he found stirringly imaginative potency in the French philosopher's meditation on symbolic and archetypal meanings. Although primarily directed towards architecture, the book's implications were far-reaching, specifically in addressing the poetic image in literary language with a forensic method that gave value to a deductive form of intelligence. Above all, *The Poetics of Space* dealt with the desiccated culture of late modernism. Rather than reinforcing the conventional view of continuities within systems of knowledge, Bachelard wrote that obstacles and events interrupt the continuum, thereby forcing new ideas to appear and to alter the course of thought.

These obstacles played a crucial and creative function by transcending rationalism and visual evidence. Space becomes the dwelling of human consciousness, or the half-dreaming consciousness that Bachelard calls reverie. He viewed reverie as the source of great poetry as well as abject sentimentality and imaginary physical theories. Writing about architecture, Bachelard claimed that: 'A house that has been experienced is not an inert box. Inhabited space transcends geometrical space' and thus submitted spatial types such as the attic, cellar, drawers, corners to systematic study or 'topoanalysis'.[60]

A flavour of this concern for existential space was present in *Night Life* (1984) (fig. 12), Crowley's temporary mural in the ICA's ground-floor gallery. It was, reported Feaver in the *Observer*, 'an exploded version of his pictures of upstairs rooms… Playing real spotlights on painted lamplight, exaggerating the angles, making dramas out of the gaping windows, the shadows behind the doors, Crowley dispels the ghosts of attitudes past and introduces his own.'[61] In this mural pictorial language transmitted the experience of architecture. Scales shifted between objects to give equal prominence to known 'things' like a wall-mounted light switch and a panorama of the night-time city. The grainy broken black outlines around objects created the impression that the entire wall space was occupied by a huge drawing in charcoal. Backed by flat, unmodulated expanses of nocturnal blue and light shadowy grey, with the whiteness of paper showing through as highlights from the wall beneath, these bold marks inhaled intimacy into the image.[62] At odds with the mechanical character of large-scale urban imagery in the consumer age (and with Crowley's own Pitt and Scott mural), the effect aroused memories of older methods of reproduction.

Three paintings made in 1986-7, however, reflect a fuller absorption of Bachelard's theory. The largest is *In Living Memory* (1986) (plate 17) and, if only in terms of its format, it was perhaps the most ambitious painting by Crowley since the square canvases in pasty acrylic which he hung on the angle at the RCA in 1975. This work comprises six paintings, each encompassing a particular 'view'. When placed together, the spaces spanned flip the viewer back and forth between inside and outside a building, between near and far, and between reflection and image. Crowley has described the effect as 'workaday Cubism', a

shuffling of spatial relationships and viewpoints within a perceived duration of time that nonetheless coheres with an expectation of a feasible image, usually through the unifying effects of consistent lighting.

Evident within *In Living Memory* is the artist's determination to examine possibilities in image-making that multiple angles of vision and discontinuous spaces could together allude to fragmented mental states, to 'basic fears: the bolt-hole blown open, the shadow creeping up the stairs.'[63] The nearest structural equivalent is not Surrealism, which Crowley was at pains to avoid, but magical realism.

The genre, in which a highly detailed, realistic setting is invaded by something too strange to believe, was popularised as a literary form by Latin American writers from the 1960s onwards. In his application, however, Crowley drew on stop-frame animation, the technique that became popular in the 1960s of creating the illusion of movement when a series of individual frames is played as a continuous sequence, and on the German *Neue Sachlichkeit* in the fine art of the 1920s. The painters associated with this new objectivity implanted a heightened realism into the depiction of mundane subject matter, revealing an 'interior' mystery. Interest in their work had been falteringly revived by exhibitions in London in the late 1970s but had been overtaken by stronger critical claims made for Max Beckmann's relevance to the emerging strand of 'transavantgarde' figurative painting.[64]

The power of still ill-defined possibilities in this genre led Crowley to carry the themes of *In Living Memory* into *The Poetics of Space* (1986) (fig. 13) and then into *Peripheral Vision* (1987) (plate 18), a breakthrough work. *Peripheral Vision* marks a significant move forward in Crowley's attitude towards transposing the contemporary into a vernacular pictorial language and, to use the artist's own expression, in 'making serious art that doesn't look like serious art.'[65] How serious is implied by the opinion of one critic, who saw in the canvases of *In Living Memory* '...in a sense, a reworking of Blake and the world of the poet James Thomson (*The City of Dreadful Night*, where the city is a symbol of man's alienation) in terms of modern S.F. [science fiction]... Nothing changes, he seems to say; progress is a chimera; man is *de*-volving into an empty presence'.[66] How they were made, with thick white impasto and layer after layer of colour glaze applied and wiped down, was intended to reflect the artist's intent. Laborious technique, in contrast with the 'painterly' neo-expressive subjectivity that was common in galleries and criticism at the time, expressed the accumulation of knowledge through tangible care and craft.[67]

One quality his paintings acquired in this time was luminosity. In earlier paintings, for example *Breakfast of Champions* (1983) (fig. 14), earth colours predominated in order to bind a composition that was conceived graphically, in the way a drawing or a print would be. Indeed, drawing was fundamental to this work and has remained so, but by mid-decade Crowley was looking at how to make an image less dependent on graphic methods. He sought to paint light as if it was real ambiental light reflected off the transparent glazing medium. The way forward was prompted by looking critically at paintings by Rembrandt and Albrecht Altdorfer (*c.* 1480-1538). The superficially uncomplicated landscapes by the German sixteenth-century artist were particularly helpful. On closer inspection, innocuous but fastidiously fabricated surfaces disclosed other significant dimensions that were sensed by the engaged observer more than they were delineated. The direction towards secondary, religious and mystical ideas was invariably indicated by the handling of light within the picture, while for Rembrandt light spoke of life itself.

Although *The Poetics of Space* and *Peripheral Vision* were conceived as three abutting canvases, Crowley had no use for the traditional description of 'triptych' often attached to religious artworks.[68] The phenomenological aspect of such painting, however, complemented the ideas that intrigued Crowley about the oneiric house. The later of the two paintings is regarded by him as closer to matching his intentions, although the earlier image was successful in being jointly awarded the second prize at the fifteenth biennial *John Moores Liverpool Exhibition* in 1987. The central feature of the middle canvas (the three canvases have different widths, the middle canvas being the widest; *The Poetics of Space* was more conventional in

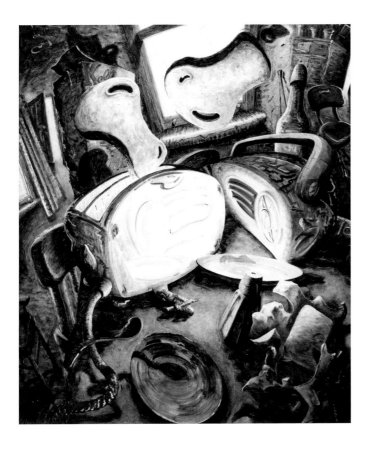

Fig. 14.
Breakfast of Champions, 1983.
Oil on canvas, 153 x 122 cm.
Private collection.

having two wings of equal dimensions) is a column surmounted by a pitched roof with a dormer window and chimneys that is quickly identified by its setting as a house without walls.

Nothing in the image implies a specific house; it is simply an old house in which families have dwelt over generations. Crowley conceived it as emblematic, a motif comparable with a heraldic device identifying one state of mind in a pageant of many. The house appears vulnerable and exposed, putting on view what should remain unseen by the outside world, and seems to float above the chaos of inner city decay. The canvases on either side take the viewer back indoors with an extension of contrasting spaces that Crowley had earlier brought about with reflections in mirrors and window frames.

He remembers from his childhood bomb-damaged houses, the outer walls of which had fallen away to reveal the wallpaper someone chose and once-loved possessions available for others to see and to judge. That memory of his upbringing in the east London suburbs of Essex in the austere aftermath of the war years continued to upset him, and informed the nostalgic and essentialist character of this work. The artist saw the image of the house without walls as an expression of empathy, and its existence in more than one version betrays the importance of this objective to him. 'Empathy' is commonly defined as 'the power of projecting one's personality into (and so understanding) the object of contemplation', of experiencing imaginatively what another person is experiencing.[69] The concept is frequently conflated with compassion or sympathy, although these need not be implied, into a process of emotional and psychological projection.

Crowley's reference to empathy can be mistaken for wistful, self-conscious subjectivity whereas it possesses a robust ideological foundation, representing his distancing from the rigorous intellectualism of stringent abstraction and the discourse of postmodernism. Empathy, and the reciprocal experience of exchange and transformation, has pedigree in art history and philosophy. Describing an embodied response to an image or object, theoretical statements dating from the 1870s examined how the status of the spectator and the idea of 'spectatorship' are affected by empathy.[70] The concept encapsulates the 'destabilising' effect

Fig. 15.
Cover design with artwork by Graham Crowley for Introducing Marquis de Sade (1999) by Stuart Hood, originally published as Marquis de Sade for Beginners, 1995. Reproduced by courtesy of Icon Books, London. © Icon Books.

on the viewer's identity of an object that is itself animated by being looked at, a situation that makes works of art particularly suited to pure optical feeling. Discussion of empathy in art was neglected in modernist theory but once aware of it, Crowley recognised in the idea a convincing formulation of his intentions. The nature of the response in his paintings is aesthetic and narrative-based and, thus, provides a stark contrast with the estrangement he disliked in Conceptual art. In *Peripheral Vision* and, later, in *The Chain Store* (1987) and *No Such Thing* (1993), Crowley investigates the concept in a manner comparable with recent critical attention to Edward Hopper's imagery, some forms of architecture and the discipline of film.

Nonetheless, *Peripheral Vision* achieves a detachment from personal history with an abundance of generic detail unified by ambient rather than local colour. The predominant tones of burnt umber, Cerulean blue, Manganese blue and pinks spread through the image like an odour or mobile light; the effect was non-naturalistic but specifics were rendered into a dreamlike haze. The buttery colour of a low kilowatt bulb illuminating the staircase and top landing in the left-hand panel was achieved with four or five coats of Indian Yellow. Crowley constructs an abode of human consciousness, one that establishes reciprocity between the artist and the onlooker who can enter this fictive space imaginatively.

A drawing in compressed charcoal from 1983, *The Sprawl no. 3* (fig. 1), prefigured this direction. Depicting a town of his own time seen from an elevated viewpoint, chimneys smoking languidly into a vault of dirty puffy clouds above the high horizon line punctuate a dishevelled thicket of pitched roofs and spiky totem-like masts of television aerials. The scene is dour and gloomy, echoing the mood of sections of the British public in the aftermath of the economic recession of 1980-1. The Conservative politician Nigel Lawson wrote in his autobiography that in 1983 'unemployment was high and still remorselessly rising; and although the pace of the rise had been gradually slowing…, recorded unemployment did not start to fall, from a figure of well over three million, until three years after I had moved into Number 11.'[71] Forecasts, Lawson admitted, for growth and inflation were also 'extremely gloomy' and Crowley, who was instinctively opposed to the government's policies, believed himself to be among many at risk from its harsher measures and restraints on public spending. The tenor of unease that his work had established around 1980 was now stepping out of the domestic interior into the streets outside.

The drawing was in a deliberately archaic and illustrative style. A throwback to the era of Victorian steel engravings, it recalled working class life in London when the city's population increased

rapidly. That inexorable rise precipitated a need for cheap housing that private house-builders and landlords met with largely unregulated, laissez-faire urban growth. What recommended this nineteenth-century source to Crowley was the pronouncement by Mrs Thatcher in the run-up to the 1983 general election of a return to 'Victorian values' as a talisman for lost stabilities. 'I want everyone to have their own property,' declared the prime minister. 'I want them to have their own savings which retain their value, so they can pass things on to their children, so you get again a people, everyone strong and independent of government, as well as a fundamental safety net below which no-one can fall.'[72]

To Crowley's mind, current political debate that rang with a resonance of Britain's past deserved an art on similar terms. The examples of Honoré Daumier (1808-79) and Gustave Doré (1832-83) appeared appropriate successors to his sources in George Herriman's output and in *Gasoline Alley* for graphic inspiration; print dissemination was, after all, common to them all. Doré's *London: A Pilgrimage* (1872) had enjoyed commercial success when new and the work was disliked by many contemporary critics concerned by the focus in its images on poverty. The *Westminster Review* claimed that 'Doré gives us sketches in which the commonest, the vulgarest external features are set down.'[73] In the mid-1980s, comparable questions about the interaction of human habitation and institutional power seemed unresolved.

Among the most familiar of Doré's 180 engravings in the series is *Over London by Rail*. It depicts a terrace of houses curving under one lofty arch while in the distance another straddles the street with a locomotive travelling over it leaving a thick trail of smoke. The visual allusion to conditions that, since the 1940s, have been tagged 'Dickensian' seemed inevitable to Crowley as, in effect, London had become a tale of two cities. The West End was the glittering playground for conspicuous consumption by a new leisured class and the East End, where Crowley had been raised, was where workshop industries and international trade combined to support a large, almost exclusively working class population of indigenous and diverse immigrant communities.

Crowley's approach to his subject matter consciously addressed arguments for a debate about the value of illustration in contemporary practice. He openly took issue with the consensus that had formed in art schools and beyond around Clement Greenberg whose denigration of illustration had crystallised into an article of modernist faith. Advocating an identity for painting divorced from other media and idioms, Greenberg asserted that '...for the sake of its own autonomy, painting has had above all to divest itself of everything it might share with sculpture. And it is in the course of its effort to do this, and not so much – I repeat – to exclude the representational or the "literary", that painting has made itself abstract.'[74] Crowley's graphic style had emerged as a riposte against such orthodoxies that had calcified into dogma protected by regularly intoned shibboleths. He valued illustration for channelling ideas to a broad audience, interpreting the idiom equally as a door ajar to wider meanings and as a carrier of information, even of the variety he had enjoyed in motor magazines.

To accompany *Night Life* in summer 1984, he made an artist's book reproducing full-page 22 charcoal drawings with a one-colour wash overlay that echoed the format of the mural at the ICA. The inspiration came from the short story by Nicolai Gogol (1809-52) called *The Overcoat*, published in 1842. Gogol's preferred form was the short story, a genre for which Crowley's paintings provide a type of visual equivalent. Gogol wrote about Akaky, a man zealously devoted to the tedious, low-level work of a copyist who is routinely passed over for promotion because of his dread of responsibility. His proscribed world is devastated, however, by the theft on the first occasion he wears it of the new coat for which he has saved for years. The ensuing trauma of asserting himself with the authorities and his colleagues leads relentlessly to his decline and death. The appeal of the plot lay for Crowley in the turn of events from despair and the supernatural revenge of Akaky's ghost to the final note of uncertainty as a policeman witnesses another assault. Equally important for the painter was the writer's style. It mixed realism with a quality known now

as surrealist, and dispelled the gloom hovering over much Russian fiction with absurdity and humour often aimed at the pomposity and the condescension of bureaucrats.

In 1995 Crowley was commissioned to provide drawings for a volume in Icon Books' *For Beginners* series, specifically to accompany Stuart Hood's monograph about the Marquis de Sade (fig. 15). Requiring a light touch for a subject still regarded as controversial, the task suited him. He was adept at leavening serious subject matter with the injection of humour while leaving its philosophical message intact. Moreover, Crowley approached his subject with awareness of Sade's importance as a radical thinker described by Aldous Huxley as 'the one completely consistent and thoroughgoing revolutionary of history'.[75]

■

The most far-reaching significance of *Peripheral Vision* and the ideas that had led to it was unexpected. It was to shake Crowley out of the comfort he was falling into with England's suburbs as centres of chaotic home life. In mid-decade, he asked himself whether he had a 'great subject', if he had more to say. Apparent over the next six years was the pursuit of simultaneous prospects. One possibility was to fragment the image more radically. The ten rectangular canvases of *Law and Order* (1988) (plate 21) resemble the layout of a page from classic British or American comics in their post-war heyday. Each painting fits in like a framed cell in the strip, each with its own spatial coordinates – exterior, interior, close to or hovering above. The multipartite work pursues the notion of a timeless reverie in existential space where increasing amounts of adversity are confronted and where cause and effect are trapped in frustrating disequilibrium.

Although that route was quite quickly rejected two other products of the period presented a greater potential: energetic, high-keyed colours and a transition to the outdoors. Whereas the anthropomorphic subjects had reflected the artist's anxieties as a new parent as well as a practitioner, paintings at the end of the decade were taking on a political commentary as broad as he, the maker, could support and as strong as the pictorial objectives of his project could withstand.

Two paintings in particular exemplify this widened perspective. The first, *The Chain Store* (1987) (plate 19), was made during his three-year term as senior fellow in painting at South Glamorgan Institute of Higher Education in Cardiff in 1986-9.[76] The second was titled *No Such Thing* (1993) (plate 29) and followed an 18-month drawing residency in 1991-2 in Cleveland on Teeside. Both resulted from extended periods of living and working in parts of the country that were geographically and socially different from London and south-east England where he had so far spent most of his life.

South Wales in the late 1980s was undergoing change from its economic dependence on the coal industry to a future based on the supply of services, including leisure. Cardiff was awaiting regeneration through plans for new architecture in the dock area to attract investment by service industries and the transformation of the bay into a freshwater lagoon with the construction of a technically advanced barrier. By 1987, when *The Chain Store* was painted, the city was in a depressed lull between these two phases of its history.[77] The first seeds of a future planted in consumption instead of production were breaking the surface on the periphery with the arrival of 'edge-of-town' shopping centres, British equivalents of continental hypermarkets catering predominantly for home improvements and do-it-yourself. In manufacturing towns where traditional employment had been undermined by the recession of 1980-1 and the contraction forced on the economy by strict government budgets afterwards, the substitution of factories with warehouse-sized shops operated by huge retail combines was ironic, especially when adult unemployment had reached historically high levels.

*The Chain Store* is an emblem for the dramatic social and cultural change of those years. Broken buildings occupy the 'brown-field' foreground and in the background a vision takes shape of office blocks and other lofty structures. In the middle, presiding over the frontier between the closely delineated present

and the hazy future, is the name 'Texas' supported by a column driven into the roof of a decaying factory like the first surveyor's peg in new territory or a stake through the heart of history and tradition. Texas appears as a corporate symbol, the brand image of a massive hardware multiple that supplied the trade and private customers whose quick-fix improvements were encroaching remorselessly on the domain of the craftsman. What cannot be deduced, however, is a directive from the artist to the viewer about the message to draw from the image. Crowley provides arguments and leaves judgement to others.

David Lee, writing in *The Times*, described Crowley as 'one of many serious painters who, without resorting to the facile expedient of scrawling political slogans across his pictures, has attempted to reflect thoughtfully upon the Thatcherite years... His sudden re-direction [from the concepts of art-about-art around 1980] was inspired by a desire to make his work accessible to more than a tiny collection of initiates.'[78]

The 'accessibility' of *No Such Thing* starts with its surface openness. At first, the ambiential colour washes the nostalgia of felicitous space over the composition. It resembles a lithographic illustration from a child's picture book of the post-war years, or a cameo that philatelists scrutinise inside the ornate frame and boldly seriffed lettering of a three-colour photogravure, inter-war definitive postage stamp from a British colonial possession. The undemanding and even banal scene of almost identical two-storey houses makes a pattern that from the high viewpoint of the painting can be interpreted as a grid of roads with little variation. It reaches beyond legibility in the painting towards an horizon consumed by light and dissolves into clouds and what may be trees or still more chimneys. At first meeting the painting asserts its objecthood in the mind of the onlooker.

The image repays close attention. For instance, by attaching the muted colours to the shadows of clouds passing overhead instead of to the details of the town, the artist appears to attribute substance (a test of reality) to the nebulous. If the spectral housing is ignored, the tonality of the painting has greater resemblance to how countryside is treated in old paintings than to the handling of towns which, according to convention, is associated with the chaos and idiosyncrasies of human habitation. Crowley intends meaning to accompany observation: this image is an early example of his interest in changing patterns of land use (in this case, urban boundaries advancing into green-field development). His sideways quoting of Rubens and artists of his time through colour flags up, to those with the knowledge, allusion to the landscape tradition. And, Crowley insists, that knowledge is worth having; it is available to those who look. With high-quality reproductions in affordable books and, more recently, through the Internet, he maintains that the opportunities to broaden awareness and to dissolve the class privilege that once restricted access to education have never been closer to hand.

The uniform grey enveloping the houses of *No Such Thing* implies a steely, unblinking gaze from the observer. The congested streets stand in the path of a row of energy pylons, the slack cables from which droop above the rooftops of homesteads nourished with electricity to power the appliances that modern society deems 'essential'. There are few people about and suspicion surrounds those who are seen standing in back gardens looking into open windows. The town has a larger population of telephone lines than humans on view; taut or slung, lines tether houses to poles like the cables of breeches-buoys to deliver life-saving telephony services to residents. (These poles must be precious to this town; they are crowned with miniature gables.)

Services like satellite television, the receiving dishes for which sprout from upper walls. It may be solitary pastimes like television that are keeping the dogs chained, the cars parked in their garages and the people indoors, cooled by air entering the properties through many an open top-hung sash. Those people may now own their homes, having exercised the 'right to buy' their council accommodation through officially sanctioned Victorian values. Thatcherite financial reforms delivered easier access to mortgages, to home-ownership and, for most, to debt.

This anodyne, even dull, townscape slips out of the confines of its genre to unite with the genre of history painting. The town as a by-product of political events merges with the surrounding generality of landscape in the painting. The air of the generic is insistent: the title leaves it anonymous; this town is 'Anytown'. For many who lived through the last decade of the twentieth century in Britain and who were conscious of current affairs, the three words *No Such Thing* still assume the response 'as society'. In an era of catch-phrases and slogans, many perpetrated by an aggressively self-confident advertising industry, this phrase became well known and well used on both sides of the political spectrum. Attributed to Margaret Thatcher in a magazine interview in autumn 1987, she asserted: 'There is no such thing as society. There are individual men and women and there are families and no government can do anything except through people and people look to themselves first.'[79]

Feaver dubbed Crowley 'the Canaletto of urban deprivation' on account of this painting.[80] Selected for the eighteenth *John Moores Liverpool Exhibition* in 1993, *No Such Thing* was accompanied by the artist's statement in the exhibition catalogue that expressed greater partisanship than the image itself. 'It's bad enough,' Crowley wrote, 'when fourteen-year-old car thieves act as if there is no such thing as society. But it's another matter when prominent politicians echo this numbing sentiment.'[81] He had gathered firsthand experience of the north-east from spending 40 days in each of the four large towns of Hartlepool, Langbaurgh, Middlesbrough and Stockton, living, working and being involved in activities that brought him into contact with visitors to local museums where his studios were located.

Acutely conscious of being an outsider who was liable to rely on prejudices and swiftly-reached conclusions, he wanted to approach the area of the Tees 'through its totality; not bring coals to Newcastle.'[82] Nonetheless, Crowley felt personal empathy with the local working population: 'Unemployment is something that personally concerns me,' he told a local journalist, 'because I have been at the edge of unemployment all my life.'[83] The precariousness of his livelihood as an artist has fed into his world view and, thus, into his imagery since the late 1970s. 'Wilfully perverse' is his own description, 'my career has demonstrated my antipathy towards the art world as I see it.' He has worked as a motorcycle fitter, picture framer, builder's labourer and car washer and mechanic to support himself and his family, an admission (and acceptance) that his choice of subject matter and his way of treating it have not placed him in the vanguard of commercial appeal.

The view he formed of the region was that the society, as a community motivated by basic shared principles, had weathered robustly the tumultuous economic changes of the 1980s which had placed the steel industry, the area's biggest employer, under duress from worldwide competition and lower prices. 'People in the North East,' he commented at the end of the residency, 'have a very different perception; they have lived so long with industry, they respond to the nuances not the totality of the environment. There is a strong feeling of local pride and people have a more positive attitude to the future than southerners.'[84]

The residency's emphasis on drawing did not require a significant adjustment in his practice; drawing has provided the basis for much of his painting since he was at art school. His exposure to what he described as the 'post-industrial wilderness' around the South Gare, for instance, which is approached 'through dumped waste, white pools and smoking slag mounds and views of one of the world's largest blast furnaces', provided an atmosphere not far removed from those he had created from his imagination a few years earlier. What Crowley responded to was unexpected beauty, to the migratory birds whose landfall was near sea warmed by the nearby nuclear power station that also attracts seals; the greeny-yellow tonality of industrial steam; the traditional pastimes of fishing and dog-walking; the blinding morning light in winter; and the 'beautiful flare of night chimneys'.[85] He regularly used photography to set viewpoints in his mind and to help imbibe particular qualities of the location. His aim, he told the reporter, was 'to make the familiar look unfamiliar' even to those who knew it well.[86]

Fig. 16.
The South Gare, 1992.
Compressed
charcoal on paper,
21 x 30 cm.
Private collection.

The contemporary charm of that environment is uppermost in *The River Tees at Yarm* (1992) (plate 28). Collage is included in the media to enhance the impression of layers of existence beneath the pellucid water plane of the river. Crowley allows himself a quote from Monet's *Nymphéas* (*c*.1919-26), updating the Frenchman's audacious, fluid study of water lilies and reflections into a flotilla of discarded condoms travelling the current. Manifested in his drawing, *The South Gare* (1992) (fig. 16), are those observations as countervailing influences; the artist's preconceived attitudes become gradually, temporarily naturalised by being within the subject. Crowley used conté chalks and compressed charcoal (his preferred medium; it leaves hard-edged marks that lie on the paper surface, avoiding the flayed, crumbled lines made by ordinary charcoal), removing material in a rubbing process called stumping to obtain a tonal range similar to those produced by glazes in painting. By wiping away the marked surface, he created highlights that contrast brightly with the black.

The pen and wash technique he used in other work on paper facilitated images in which massive buildings dematerialised into a predominance of light and reflection modulated by climate and pollution. Letting go of detail in these works cross-fertilised with small-scaled paintings in oil paint on board that rephrase the motif of rooftops, chimneys and sky into inkblot-like marks.[87] In *Small Black City* (1991) (plate 26) marks are brushed in or wiped away, cast under sky rendered with right-to-left sweeps of the brush. They anticipate his paintings of the west of Ireland almost a decade later and his nocturnal view of a London suburb, *Crystal Palace* (2000) (plate 36).

At the same time Crowley pursued in drawings the hybrid genre between landscape and history that had been partly initiated by *The Chain Store*. Integrated with the particularity of observation is a licence for critique of the social reality of the location (and how it may feel to inhabit it) and of the contemporary purpose of image-making. In *Power Station* (1991) (plate 25) Crowley portrays a monumental rectilinear structure that strangely updates the chilling magnificence of Piranesi's looming architectural spaces. Chiaroscuro contrasts of charcoal black and stumped highlights articulate the building's blind, unfenestrated flanks and jutting angles. The picture plane is crisscrossed by a mesh screen which, on looking more closely, is revealed to have been collaged over the paper on which the image was drawn. It is the screen that keeps in secrecy and keeps out unauthorised personnel, a category extended on this occasion to the bystander in the gallery.

Fig. 17.
Silo, Middlesbrough, 1991.
Pen and ink wash
on paper, 21 x 30 cm.
The artist.

The title contains a double meaning. It alludes both to the job of the advanced gas-cooled reactor to produce energy and to the controversy surrounding nuclear energy, specifically its safety, in the 1980s. The Thatcher government had been firmly committed to nuclear power while the architecture spawned by the technology seemed alien to flat, coastal locations where the reactors were sited. To left-leaning sections of the community, these unyielding bastions symbolised Thatcher's policies.[88]

Detectable in his work at this time is a credible reason for Crowley's interest in and enthusiasm for Bachelard's theory of oneiric space. In Crowley is an echo of the nostalgic and essentialist world view which makes Bachelard's meditations on the topography of dwelling appear historically dated. And like Bachelard, it is the interrelationship between experiment and experience that gives Crowley's imagery a radical potential. So it is with *No Such Thing*: Crowley sets what he sees next to how he sees it at that point in his and the nation's life. His inspiration was Dormanstown, a suburb of tied residences created in 1917 for its workers by the iron and steel manufacturer, Dorman Long. Located on the doorstep of the seaside town of Redcar, the town's fortunes shadowed the performance of the innovative steel producer whose patronage, in what Crowley interpreted as the last gasp of feudalism, had brought it into existence. It declined in the 1970s and 1980s with low investment and unemployment and although it recovered in the next decade with increased levels of private home ownership, the town could still be described as suffering with 'the inner-urban deprivation that is all too often the concomitant of a damaged industrial base'.[89]

This hybrid genre had been taking shape in the five years before *No Such Thing*. On his return to England from Cardiff in 1989, Crowley and his family had moved to a 300-year-old home near Staunton in the rural setting of the Forest of Dean in Hampshire 'to improve our quality of life', he told Feaver.[90] Among the 13 paintings completed in 1991, shown that year at Edward Totah's West End gallery, was *Suspicion* (1991) (plate 24) in which the centre once again exerts insistent, graphic prominence. A single, small-sized trainer lies on its side in water that fills tyre tracks imprinted in the soft floor of a forest clearing. His technique sets the scene with as much eloquent clarity as the image itself. Fully worked out in white impasto, the composition takes shape chromatically with '"boiled-sweet" glazes', to quote Feaver.[91] Wands of light emerge naturally from within the strict tonal range of the painting to beam forward from the imagined interior of pictorial space through leafless trees. The blaring luminosity suggests morning, with the dawn sky reflecting limpidly in the puddles. Oil paint demonstrates that it can be gloriously sensuous, but its qualities are set by Crowley in contradiction of the nature of the image. The weather-lore rhyme, 'Red sky in the morning; shepherds warning', comes to mind with its broader association with foreboding and sorrow.

The dark side of landscape is often made apparent by Crowley's infusion of light. He had scrutinised both the subject matter that surrounded him and the conventions that had been traditionally attached to its treatment in fine art. In this regard, John Barrell's book, *The Dark Side of the Landscape: The rural poor in English painting 1740-1840*, an innovative study published in 1980 of the changing attitudes towards the depiction of landscape in English painting during its 'golden age' from the mid-eighteenth century, had a profound effect on him; it was comparable with the impact of Bachelard's writings on his idea of inhabited environments.[92] For although there is no doubt that Crowley likes where he lives (although he paints a generic rather than specific view, it is informed by experience gained and observations made when walking in and travelling through the area around Staunton) his truthfulness does not permit him to use the standard language of his peers and predecessors. Comparison with the position of John Clare, the nineteenth-century Northamptonshire poet, is not far-fetched in this context. Clare lived most of his life where the old landscape was being transformed by enclosure and had to find his own language to write his knowledge of the individual locality. His success at this task also removed him from the mainstream of English poetry.

In *Encyclopaedia* (1991) (plate 23) Crowley proposed a route to encompass convention and dissent. The landscape is perceived as monochrome, sky as lowering and trees as leafless sprouting columns, resigned to being 'a resource', raw material for the telephone poles that plug Dormanstown into the information superhighway rather than the expression of cyclical decline and rebirth. The identity of the forest assumes the neutral tone of a passive victim of circumstance. Having shed the rustic rhetoric of pastoral romanticism, it doubles as foreground, through which grey light rushes towards the picture plane like water through a filter, and as background, to the unusual roundels hovering in confectionery shades containing images of industrial production.

Borrowing the layout of the educational comics of his own adolescence, such as the popular titles *Look and Learn* or the *Eagle* and Lawrie Watts' drawings, when cutaway details and superimposed cameos of useful trades cast the light of fruitful resourcefulness on science and nature alike, Crowley simultaneously reverts to warm memories of innocent youthful curiosity and undermines that lapse into reverie with reminders of the inescapable underside of the modern countryside.[93] 'I'm trying to make a happy marriage of history and the experience in the cross-over between innocence and knowledge,' he admitted.[94] While rural England is beautiful, it is tarnished, spoiled and exploited legally and illicitly in much the same way as man is made use of by fellow man. A figure who may be a poacher roams defiantly in two paintings from this clutch.

'No artist worth his salt today is unaware of the terrible choice. How to do it? What idiom to do it in? Working at the bottom of that, in the darkest recesses, is the worry: what personality to affect? That really *is* treacherous waters.'[95] Crowley's confession to Feaver highlights the doubly precarious nature of the career of an intelligent artist who is ambitious and optimistic about the prospects for his medium. Articulated as enquiring interrogatory, the statement is symptomatic of Crowley's general prospectus about his profession: questions about the value of painting at any particular moment he is living through propel his choices of subject and technique, and the syntax of genre to which they conform.

Some observers may maintain that by the beginning of the 1990s neo-expressionism, already in decline, had sunk under the weight of its mediocrity. Painting was finding its place in the heterogeneous territory of post-Conceptual production. Although the medium was by no means perceived critically as a rump, object-making held much of the limelight. Time-based media and installation achieved promising maturity and, as a sign of the times, became widely popular as elements in a neo-Conceptual art. Painting seemed to adopt ambivalence as its defence, between abstraction and representation, for instance, and between attempted suicide and a belief in its own future. Through Gerhard Richter's prominent position as an unsentimental and perhaps cold-eyed conduit, all this opacity flowed; his painting was a mirror held up to monitor the medium's vitality.

Unexpected parallels exist between Crowley and Richter. Both painters ask people to think afresh and not romantically about what they see in an image and to question the trust they place instinctively in what they see. And as painters, both acknowledge photography (still or moving) as the medium through which most imagery is transmitted to most people, an inescapable fact that also raises questions. Neither artist presumes to answer those questions. Richter has pursued his scepticism with a global reputation, giving his practice an international standard that grants permission to others.

Crowley's reach has been more modest; teaching, however, has amplified the influence of his paintings. (In 1996 he was appointed head of fine art at City and Guilds of London Art School and, two years later, he returned to the RCA as professor of painting.) He was brought up in the tradition of the sceptics; he is not a cynic, he argues, because cynics would not choose to paint. Both he and Richter invite the viewer to reflect on contemporary politics and history as well as the mechanics of the thing they have made. Whereas detachment is a feature of their paintings – Richter distances himself from the clichés of artistic expression through his compulsive use of source material, often photographic, to compose landscapes, abstracts, portraits – there is no sterility. They are true believers in painting, to the point of being regarded avant-garde as old-fashioned traditionalists.

■

Like Richter, Crowley has looked for the 'space in between' the idea and the conventions of expression. His decision to review critically and reclaim for modern painting at a high level the genre of flower painting became, perhaps, his most radical. Flower painting's status for the avant-garde as a low brow activity, the domain of the amateur, was a spur to the genre's adoption. Another was Crowley's increasing awareness as he rode around London or other large towns on his motorbike that the popularity for floral tributes at the sites of traffic accidents or other everyday tragedies was rising. Blooms in cellophane packaging could be seen propped, Sellotaped or wedged at kerbside barriers or boundary walls, often wilted and drained of colour, as lifeless as the victim they mourned.

Thus the flower had become reinvigorated with content. Demonstrations of grief had become more public and more communal, a repository of meaning as robust as the memento mori or the exuberant sprays celebrated and prized in seventeenth-century Holland.[96] Crowley looked at Dutch examples of the genre as prime instances of an art brought into being by its patrons, businessmen who distrusted idealisation. Although Crowley objects to symbolism, his commitment to building a second order of meaning into imagery was intensified by knowing that Dutch genre panting carried a moral message expressed ambiguously. To achieve it, Crowley overturned the values of genre and, in the case of the flower paintings, he 'wanted to make it unacceptable to the cognoscenti' (horticulturalists, one suspects, as well as art historians and theorists).

The presence of his project within recurring subject matter is strong in the flower paintings. Although the first canvas was embarked upon in 1988, most of the rest date from the six years from 1992. The largest in size, on human scale, share the same title, *Flower Arranging* (plates 20, 30-3). As many as eight of them can be imagined installed together in one room or gallery with the intention of making a point. That point was located in the paintings themselves, in the nature and colour, scale and detail of the image, and in their common title. Out of the word 'arranging' spill insistent overtones of being directed against organisation in the formal sense applied to modernist art.

Indeed, these arrangements are distinctive for not being banal; they are irregular, dynamic and even uncouth. In *Flower Arranging (6)* (1998) (plate 31) the anticipated vase (probably a jug into which the stems were plonked) has been cropped; and in *Small Flower Painting (1)* (1998) (plate 33) – one of several small paintings Crowley made after completing the large-scale canvases – it is the flowers that are almost lost. Viewpoints are close up, physical and provocative, and neither rhetoric nor hubris intervenes. These

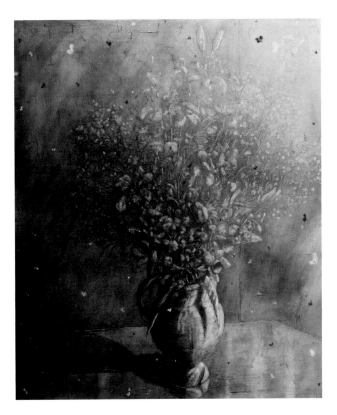

Fig. 18.
Flower Arranging (8), 1998.
Oil on canvas, 137 x 114 cm.
The artist.

qualities sit as tensely together as in a late large-format photograph by Richard Avedon or a portrait by Robert Mapplethorpe. And like those photographers, Crowley resorted to monochrome for its sensuousness and absence of poetry.[97] The images project an impaired exquisiteness which, being less than beautiful, appears more perfect. Yet the particular medium in which each of these images has been made is inextricable from the object that supports it and advances a model of aesthetic response that simultaneously prompts pure optical feeling and engages emotion and imagination. John McEwen adroitly concluded from Crowley's solo exhibition in 1997, the highlight of which for the writer was the floral subjects, that his paintings demonstrated that 'there are still plenty of things that painting alone can do. He turns the tables on the conceptualists with their gallery-guzzling installations and time-consuming videos, revealing a new poetry and richness of his own.'[98]

The series was developed alongside paintings based upon landscape that he was making in the Forest of Dean, Cleveland and in rural western Ireland, where he had moved in 1994 to live part of the year close to the Atlantic coast near Cork. Each painting began with mapping out the image in Titanium white; the alkyd base within the paint contains firm setting properties. By working up the under-painting with hog-hair brushes, the edge of a mark was held, contributing significantly to the visual impact of the drawing within the image. When the under-painting had dried, colour was applied in glaze washes. The choice of palette contradicted the historical model from the Netherlands where strong colours were used to affirm the painting as an object acquired to indulge the owner's sense of worth and position. Colour is celebratory while Crowley's inspiration was decay echoing death. Eschewing local colour, the surface was glazed with Payne's Grey or, in more than one instance, built up with charcoal grey over cobalt violet.

Details matter; Crowley invites the spectator to pay attention to them. The marks of paint wiped away or scored by the handle-tip of the brush remind the eye as it travels the surface of the physicality of the act of painting. The craftiness of skill and intelligence resides in that act to create an object fabricated with inert materials that resonate with the world of actual phenomena while remaining separate from it. Like

Crowley's towns and landscapes, these plants are anonymous and may be fictitious: ideas of flowers as infelicitous blooms with an attitude, as tribunes of nature uncoerced by man.

Some of those phenomena intrude on this parallel, pictorial world. Crowley does not make interpretation easy but blobs and ticks invade the picture plane like visual pollution or aerial interference. Some are white and advance on the visitor's space like the flaying plug on the pugnacious kitchen appliance in *Kitchen Life* (1981) (plate 11). Others are dark and recede into the space of the picture. The idea that they are pollen releases the itchy, irritating prequel to floral propagation. That they are flies scatters the ashes of morbidity over the image, like the insects in cartoon animation that buzz around a carcass or joint of meat to signify that it is rotting.[99]

Visual interference slightly reminiscent of the 'snow' that used to fall across the picture on television sets pits the surface of *Black Bureen* (2000) (fig. 20). In televisions, the condition alerts the viewer to a problem with either transmission or reception. In painting, it could perform a similar service. In the late twentieth century the problem in televisions was often resolved with a tweak of the aerial. In the twenty-first century communications have become so sophisticated that these practical, home-based solutions have been removed to remotely, unseen control centres. To rectify a fault requires contact with a service supplier's call centre on another continent; a hunt for a password and long-forgotten, randomly-composed account name. A game of hi-tech and IT dungeons and dragons ensues through subterranean fibre-optic cables and invisible airwaves before a block is lifted, a code re-set or a channel adjusted. Crowley's antennae have been set at the fine edge of communicating in images for decades, installing intellectual circuitry behind the visual screen of the picture plane. Life has caught up with Crowley's paintings; they are the fine art equivalent, as far as the medium's conventions are concerned, to 'banging the set' to obtain a better picture. The flecks of white are reminders about the subcutaneous power of imagery.

Linear counterparts of the blobs and flecks are the telegraph lines that swing across the foreground of *Black Bureen* from post to post to the gables of unwindowed houses. They are pictorial snares, catching the unwary visual intruder with improvisation as simply effective as the defences by the Home Guard in wartime Britain. Cat's-cradles of wire were prepared to baffle and trap invading parachutists and to signal the scale of task ahead. A whiff of the ingénue surrounds Crowley's painting of tufty hedgerows, broccoli trees and inky shadows. But like Blighty in 1940, this image is no push-over. Detail tightens the ring of truth about landscape, that it is often banal, full of the signs of human occupation and life-enhancing.

The hummock at the centre of *Rineen 98-2* (1998) (fig. 21) is ringed by mowing trails that accentuate nature's buxom contours, and only traces in the historic wood suggest there have been people in it. Colour-lessness is another baffle; the mind reads into and beyond the rose-tinted view. By eschewing local colour for monochrome, Crowley casts doubt on the substantiality of these places and whether they are places at all or, like the flowers he had been painting and in the words of one writer, 'beautiful fictions'.[100]

In a brief sequence of paintings, however, Crowley stretched beyond monochrome. In *The Priests Leap* (2000) (fig. 22), a taut panorama of foreground impastoed arboreal clumps and assumed distant forest screens evaporate into an inferno of yellow-glazed light that pushes to right and bottom floating varnishes of cobalt and blue dappled by a spreading rash of shadows in Payne's Grey. The profusion of rounded and curly marks that cut trees into silhouettes or fields into zones of undulating marks have the sharp, light-catching edge of chased metal with a suggestion of burr, an overall effect that is like a minutely etched plate, inked and wiped and ready to impress.

By the turn of this century, Crowley was steeped in art history; his use of this knowledge was typically unorthodox. His sources from the past allowed him to develop ideas with the grounding and 'track record' that history supplies. Treating them with the utmost respect and seriousness nonetheless did not withhold from him the licence to combine precedents from across centuries. Consequently, *Tents* (2000)

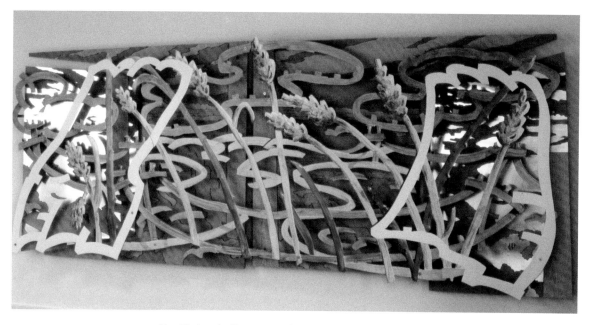

Fig. 19. Inside Out, 1998. Stove enameled aluminium with wood veneer marquetry. Relief mural in Dorchester General Hospital. Fabricated by David Beales, London.

(plate 35) contains traces of pastoral scenes from the Dutch Golden Age, American regionalist landscape painting from the interwar years, and the work of his contemporaries. Crowley's regard for a younger generation of painters is genuine and informed, paying particular attention to the directions taken by RCA graduates David Rayson, George Shaw and Michael Raedecker. Peter Doig was a tutor at the college, first appointed by Crowley's predecessor as professor of painting, Paul Huxley. His sensual painting captures on a large scale isolated, intimate moments of tranquillity that seem to exist in past memory and which are experienced in a visual language that avoids clichés. Crowley sees correspondences between the imagery of this painter and his own 'magic realist' work. He also relates to British neo-romantic artists John Minton, Alan Reynolds and Graham Sutherland whose paintings and graphics he began to look at critically towards the end of the 1990s, having been aware of their work since his own career started.

Most significantly, however, is the attention Crowley played to lessons derived from Dutch painting from the seventeenth-century. The value in referring to the northern European tradition of the landscape genre lay in two characteristics of the Dutch approach. The first concerned the nature of description, and the example of Hercules Segers (1589/90–1633-8), the painter and printmaker and influence on Rembrandt, was foremost for Crowley. Against a trend towards naturalism, Segers intensified the established mode for creating imaginary landscapes into which were transposed existing buildings, and the trees and woods he saw in the low-lying plains where he lived.

Two types of landscape predominate in the small number of surviving canvases by Segers, both enlivened by thick impasto and a rich though restricted blond palette. These types span the extremes of deserted valleys surrounded by wild rock formations and panoramic views of rhythmically arranged fields where no human figures are visible in the forests and among the dwellings. The foreground and centre can sometimes appear almost immediately below the viewer who can then imaginatively step into the scene, a notion Crowley has long liked to imply in his work.

Printmaking and not painting was the likely focus of Segers's creative and experimental energies; according to one authority, 'All the prints have the character of experiments'.[101] Individual impressions with coloured inks were printed on to paper or linen prepared with coloured grounds and then often worked up

Fig. 20.
Black Bureen, 2000.
Oil on canvas, 114 x 137 cm.
Private collection.

with wash. Moreover, he frequently cropped his prints to obtain different compositions and made counter-proofs which he repainted. None of this technical virtuosity was regarded then, or is viewed now, as original; precedents existed in Altdorfer, Adam Elsheimer (who painted on metal) and in German chiaroscuro woodcuts.[102] Segers' relevance to Crowley is that he transformed existing styles into a personal idiom. And as for graphic techniques generally, his historical value lies in the combination of these techniques beyond the limits of each of them. Crowley's *Green Day* (2002) (plate 42) displays indebtedness to this source. 'Everything is constructed,' he says about these paintings, 'space, form; they are never simply depicted.'

The second quality in Dutch art that Crowley reveres is the availability of layers of meaning that give validity to parallel interpretations of the same image. This device was used by Segers; his desolate valleys conveyed a sense of human frailty. Viewers were attuned (and the contemporary consumers of seventeenth-century Dutch paintings by and large were) to reading metaphor into the resonant topography of painted scenes. Today those meanings cannot be interpreted with certainty as the numerous source books of the time that proposed and solved visual puzzles have been lost. This uncoupling of image and meaning by historical misfortune appeals to Crowley because comprehension is left speculative. But the artist is also optimistic of cultivating a comparably literate and attentive audience in modern Britain which is not dependent on class or educational attainment but on an individual's interests being roused. The absence of clear meaning due to interrupted transmission across the centuries strikes this modern painter as an ideal outcome for an epoch preoccupied with gathering information quickly at the expense of acquiring knowledge slowly through reflection.

For this endeavour he identified the paintings of Jacob van Ruisdael (1628/9-1682) as the most appropriate models. To the modern eye their strength often lies in the depiction of picturesque elements under dramatic climatic conditions. Ruisdael painted dunescapes and landscapes with large central motifs, such as ruins, waterfalls and forests of oaks. Motifs advanced a network of ancillary meanings, ranging from the moral dimension of the transitoriness of human life and universal composites of opposing natural forces, to an augmented realism.

Ruisdael's images are almost unique in recording trends of enormous economic and social importance to the emerging Dutch republic. Although his manner is understated, it nonetheless did not belittle their significance.[103] Specific developments in the countryside, for instance the increase in grain cultivation, would have resonated with his contemporary audience. Dutch town- and landscape paintings often monitored

events on the land (more than they did the activities of people) and once deciphered, these images overspill the limitations of moral metaphor to document how life in the country almost 400 years was perceived by its people.

The multifaceted, semiotically-alert perspective that Crowley wanted to adopt on his rural surroundings in western Ireland was thus prefigured in Ruisadel. 'They broadly depict the landscapes where I live and work,' he wrote about his most recent paintings in 2001. 'I am trying to reflect the dramatic changes that are going on in the Republic at the present. I work in the landscape genre in order to refer the spectator to the idea of painting as a discourse, rather than simply an object or an activity. In these paintings I am referring to two primary characteristics of paintings: the image and the object. If there is any discreet subject matter it is the patterns of habitation, both permanent (houses) and tents (temporary).'[104]

Those patterns were changing when Crowley began to spend appreciable amounts of the year near the harbour town of Skibbereen. Although West Cork traditionally relied on agriculture and fishing, tourism had become very important to the local economy. He had visited southern Ireland at intervals for several years and saw for himself the changes delivered to the area by periods of rapid economic growth in Ireland that began in the 1990s. Growth slowed in 2001, only to pick up pace again in 2003, continuing until further contraction occurred in 2008. Government fiscal policy and investment in infrastructure by the European Union had fuelled Ireland's 'Celtic Tiger' economy, attracting immigrants and corporate investment to Irish cities, including Cork. As personal incomes grew, town-dwellers either resettled or bought second homes in the country, and the extension of the suburban rail network made excursions to the coast easier. Crowley registered these changes in his paintings. Houses with exterior walls painted in pastel or bright colours were a relatively new phenomenon in the area, having been unknown up to the early 1980s. And the colourful tents of holidaymakers had begun to appear in profusion against the weathered background of fields and trees like peripatetic blooms.

His landscape paintings from the late 1990s onwards set the scene. They do not define the territory, however, nor do they make judgement on the changes in land use that are recorded in them. The viewer may infer comment through choice of subject, but any conclusion remains that person's. Crowley's focus was on a genre that had returned to the forefront in the work of younger artists using traditional media.[105] 'For a painter,' Crowley commented, 'landscape is a genre that is inescapable; you have to address it. It's like gravity. I also felt that by the early 1990s contemporary references to other art had become culturally normative, a new kind of formalism if you like.

'Appropriation,' he continued, 'which started off as really daring, had turned into orthodoxy; it became compulsory at large to refer to other work. I was out of sympathy, too, with the direction taken towards the "abject" as a theme. It was not sustaining in a humanistic sense. I felt strongly, and still think so, that to be sustainable painting had to become emotionally nourishing. What I consider shortcomings in other paintings I see has the effect of compelling me to paint, to advance my proposition. This discourse with the present, the recent past, with history, is so important; and I have the desire to be affirmative about it. So I wanted to make paintings that were intelligent without being didactic in demonstrating that intelligence, and apply it to something accessible. I am one of nature's instinctive socialists: everyone should have their opportunity to be exposed to painting.'

.

Change was also about to affect his treatment of the landscape. Crowley is bound, by his upbringing and personality, to the work ethic. He does not mask the admission as his compulsion to work has ensured that in a career divided between several professions, all individually time-consuming and mentally demanding, his output of paintings has been notably prolific.

There have been brief periods when he was unable to paint (for example, at the end of the 1970s) and when his energies were directed at tasks more socially transparent in their values than his studio practice, such as the public art and large-scale commissions in the mid-1980s. He was, however, aware of overdemonstrating in his painting his attitude to being usefully occupied, a conclusion hastened by the diagnosis in 2002 of repetitive strain injury (RSI) in his right arm.

The condition made the detail and painstaking effort of his technique with impasto impossible to sustain. Painting became too painful and he stopped for six months. *Morning* (2002) (plate 43), derived from a view in Donegal, was one of his last works in this technique. With no allusion to his own predicament, the painting shows houses set at angles to withstand the onslaught of heavy weather. Nor was there a deliberate 'signing off' in figuration embedded in white under-painting, with glazes from Indian yellow to Cobalt Green Pale laid over and wiped down. Crowley boasts about being a painter without a palette; colours mix on the surface and transitional tones emerge as they meld into each other. Writing about this painting, he acknowledged his fascination for the area that nourished observation: 'Most mornings, the mist would slowly lift to reveal the landscape piecemeal. Colour would gradually come to the landscape. It was like watching condensation clear from a mirror.'[106]

Abandoning the technique required careful assessment. It had delivered the impersonation in paint of that gradational emergence of place from climatic phenomena that he strived for. Its adoption had been partly dictated by his objectives in giving figuration potency in several simultaneous arenas. Once content was established in the 'sea bed' of impastoed ridges and lower-lying troughs that delineated the picture, he found he could move beyond subjective imagery to play free, as it were, with colour, tone and inner luminosity. Equally important was grisaille's role in his manifesto of dissidency: he painted against the grain of the prevailing orthodoxy. Above all, these works revelled in the seductive physicality of paint.

On the other hand, the labour objectified by technique was at risk of becoming a trap, a style supported by repetition. He had not been painting in that way to prove he was smart; in a sense, his reclamation of grisaille had been an analysis of painterliness, a sort of cut-away drawing of what is needed to paint 'with facility'. His systematic method, indeed, is built upon drawing; and the disciplined and systematic processes of printmaking appear surprisingly relevant to a discussion of Crowley's paintings.[107] What is displayed in its acquiescence with Crowley's demands is painting's innate sophistication: as he confessed to this author, 'painting always makes you feel stupid – why live?' Although forced upon him, Crowley accepted in an affirmative manner the reality that his way of working had to change. It cleared the decks and restored to him sensitivity to the root phenomenon of painting.

The type of painting he then concentrated on had been underway since 1996; parallel practices have been a feature of his career.[108] 'Wet on wet' in appearance, the creation with oil paint on board of tonal effects like a photographic negative were in fact achieved by layering dried areas of monochrome with Liquin. This quick-drying, non-yellowing medium is used as a barrier layer which dries to a semi-gloss finish. Brush strokes appear freshly frozen and colour seems extended and, in John McEwen's opinion, 'narrowing and even blurring the margin between the subject and the mark depicting it.'[109] The reaction to these landscapes of longtime observer of Crowley's work, William Feaver, gave confidence to the artist: '...what shines out from the views, individually and as a group, is a sense of excitement, and rediscovery.'[110]

Rediscovery went deeper than Feaver may have known. Crowley first visited western Ireland as a 19-year-old when 'my knowledge of Irish culture and history was almost non-existent. During that visit, it was as if I had woken up from a coma.'[111] Other visits followed and his interest in recent Irish history grew, but it was not until he had become a husband and father that his own Irish background was made known to him. His paternal grandfather had been Irish and Catholic, a revelation that surprised Crowley because he had been brought up in London's Essex suburbs to consider himself English and Anglican. His mother

Fig. 21.
Rineen, 1998.
Oil on canvas,
40 x 50 cm.
The artist.

may have had Romany ancestry but it was his father, with a desire both to conform to the dominant social hierarchy common in his circumstances and to assimilate locally, who masked his mixed parentage more effectively, even gaining membership of the Freemasons. For it was not until he was an adult that Crowley discovered that, through his paternal grandmother, his father was Jewish.

One attraction of West Cork for the artist was its physical embodiment of interconnected strands of Irish history. Michael Collins, the prominent Free State politician, had been born in a town on the road between Skibbereen and Cork, and was assassinated in an ambush by anti-treaty forces at Béal na mBláth, near Skibbereen, in 1922 during Ireland's brutal civil war. The ambush took place on what had originally been a 'famine road', a track laid by poor people as a condition of receiving famine relief; similar tracks scar hillsides across the west of Ireland. Skibbereen, where Crowley bought a cottage, suffered terribly in the Great Famine (1845-9), giving rise to the mournful national song *Dear Old Skibbereen*. The town had unimpeachable credentials in the history of Home Rule, while at Bantry the harbour had been the site of the attempted landing by French troops in 1796 to aid Wolfe Tone's rising against the British. The man who raised the national flag above the General Post Office in Dublin to signal the Easter Rising in 1916 was from Skibbereen and the green, white and orange of the tricolour feature in Crowley's paintings, most prominently in *Crowley's (Killorglin)* (2002) (plate 38).

Thus, the question of identity has more than superficial resonance in his imagery since the late 1990s, and has become more pronounced since 2002. Identity is not restricted to Crowley's Irish heritage or residency as these concerns are not apparent to the viewer. Crowley does not make overt reference to his personal biography, preferring in the most recent work to 'stand back' from the image more than at any time in his career. Instead, the suspicion that pictures are arrived at by mechanical means is strong and confusing. Technique has retreated so dramatically in *Red Terrace* (2003) (plate 47) from the intense modelling in white impasto of only two years before that the painting may be a reproduction of itself, a plate in a 1950s book made with colour blocks for offset lithography so generous in their layout that the unpredictable register of the presses is amply masked.

The main question of identity, therefore, returns to what it means to be an artist in the twenty-first century. It emerges from the surface in a manner comparable with the terrace of houses. The motif becomes visible from the sparest setting to culminate in a blank end wall. Cadmium selenide, a red pigment, vivifies the all-over, non-naturalistic environment. For painters, cadmium colours (yellow, orange and red) are the most potent to use. Derived from metal they import for Crowley 'the joy of the physical world'. The houses are located by the merest amount of detail: a suggestion of a kerb, a street lamp and the shadows from vegetation sprouting in a verge hard up against the canvas edge. For its credibility, the view demands complicity in the mind of the spectator, a willingness to see beyond the visible to reflect equally upon what is absent as what is there.

The coloured ground in *Red Reflection* (2005) (plate 54), the painting with which Crowley was named third prize-winner at the twenty-fourth *John Moores Liverpool Exhibition* in 2006, has no greater symbolic value than to assert the contemporaneity of painting. Red is traditionally the colour of danger or excitement in art, and when Crowley was asked whether his use of it was connected with the 'slaughter of the local landscape', he replied that it did not. But it marked out the cost of losing land to development as industry and towns spread to accommodate new ways of working in an enterprise zone or new patterns of habitation in society.[112] Whereas the theme of the precariousness of life and location is present, it is not signified by colour. Change is connoted by technique, by how the reflection of a group of dwellings in water can appear as substantial as the buildings themselves when shadow, rather than light, shapes the view. If light were to disappear, the artist seems to imply, so would the hamlet. In reality, as it were, both views are equally fictional.

Consequently, Crowley treats substance and reflection alike. The ground is applied to the canvas; once it has dried, the local colour in a house wall or puddle is painted in and allowed to dry. The layer of Liquin follows and with charcoal grey the graphic element is added with a brush, wet into wet, or shaped with a cloth that wipes paint away to make a 'negative', a mark that converts black line into shadow. Over a second layer of Liquin, Payne's Gray is added, and its intensity is varied by dragging the paint or using the surface as a kind of mixing palette. The method ensures luminosity and directness, and an intelligence about the lines that goads the viewer into filling gaps that Crowley's drawing deliberately opens.

Two notable features articulate these paintings. The first is the balance Crowley strikes between his key motifs of buildings and their surroundings, and the second concerns the predominance of the horizontal format. The invariable combination of nature and man-built structure is presented in varying proportions, held in place by the colour accents of roof or wall. The balance may favour nature, as in *Pink Evening* (2005) (plate 53) or veer towards man in *Back o'Leap* (2007) (plate 56); rarely, as in *Untitled* (2007) (plate 57), nature has the picture plane to itself in a momentary return to the high viewpoints of earlier canvases.

All, however, are in the format called landscape. The *Flower Arranging* series was the last vertical run of pictures, a format in part dictated by the subject. If vertical is an urban orientation, the horizontal repose of landscape is a pictorial convention that Crowley accepted as the expected window of illusion across which his rule began to apply. At the same time, rural living suited Crowley and his way of working, and on his retirement from the RCA in 2006, he settled permanently in West Cork.

A model for paintings he has described as 'less wilful' was found in the work of the painter David Milne (1882-1953). Milne was a modernist who had been included in the Armory Show of 1913; Matisse's Fauve paintings and Monet's aesthetic unity were the strongest influences. He began his career as an illustrator and his paintings retained the calligraphic quality of his drawing. He worked as much on paper as on canvas, and in pursuit of his goal of the optimum print he invented a method of making colour drypoints. The critic Clement Greenberg named him as among the three most important artists of his generation (the others being John Marin and Marsden Hartley) but he is now hardly known outside his native Canada.

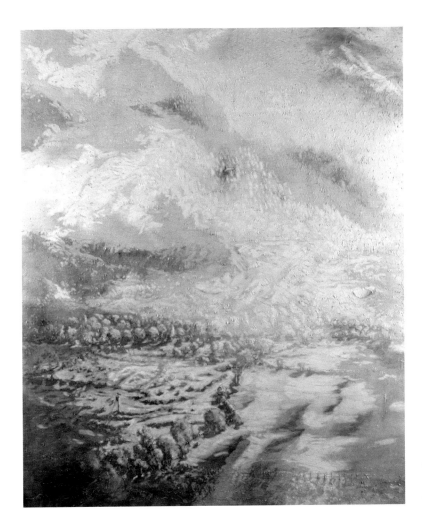

Fig. 22.
The Priest's Leap, 2000.
Oil on canvas, 137 x 114 cm.
The artist.

His importance for Crowley lies in an austere aesthetic that reduced complex subject matter to line, colour and tone. He was dubbed 'the master of absence' by a fellow Canadian painter for his ability to leave out everything but the most essential elements in a painting. A trait of his later paintings is the 'dazzle spot', an area in a composition where detail is blanked out as if by a bright reflection. It quickly draws the viewer into the painting after which the eye travels slowly around more detailed parts. Crowley's coloured houses perform a similar function; in *Green Lane (2)* (2004) (plate 49) the device is materialised as a puddle.

Milne argued that subject matter had nothing to do with the aesthetics of painting which was, arguably, his principle concern. Crowley agrees although the two men reached their relative position from opposite extremes of the modernist programme. Their distinct trajectories make the affinity between them the product of coincidence rather than emulation.

In *Blue Drift* (plate 60) and *Red Drift* (plate 61), both from 2009, Crowley reaches for the optimum expression of his aesthetic. The reflection in water of a few houses in West Cork snares the transitoriness of light into an image of permanence, while the scene above the waterline has been edited from view. The reflections of clouds assumed to be passing beyond the frame puncture the monochromed ground with cameos of detail and texture that hover like the inversions of reality they are. Stability is a chimera; when global warming threatens to raise tides and flood low-lying plains and islands, the fantasy of reflected 'normality' may prefigure the whole planet's fate. Yet it is also an image of outstanding assurance, free of nervous energy and riding knowingly on the cusp between the everyday and the great subject. These are romantic images: they celebrate life and do not set out to analyse it.

# Notes

1. John Roberts, 'Graham Crowley: AIR Gallery, London', *Aspects*, 19 (summer 1982).

2. Graham Crowley in conversation with the author, London, May 2008. Quotes throughout this essay come from conversations with the author in May-December 2008 unless stated otherwise.

3. Quoted in John Forster, *The Life of Charles Dickens*, Chapman & Hall, London, 1933 (ed. cit.), p.23. Dickens described himself as having been a 'very small and not-over-particularly-taken-care-of boy'. (Ibid. p.7.) The phrase also applies to Crowley's childhood.

4. Strutton uses drawing, installation, video, animation and performance. With Miller he founded 39 in 2003 and was Crowley's colleague as a painting tutor at the RCA where he had studied in 1996-8.

5. Crowley has taken his fascination with cars and motorcycles with him into adulthood. He has built, restored and ridden classic motorcycles and has attended the annual 'TT' races in the Isle of Man and the Manx Grand Prix as a spectator most years since the 1970s, more recently with his sons. His paternal grandfather was a keen early car user and his father enjoyed the engineering aspect of motorised transport.

6. Romford's population had increased from 38,000 in 1935 to 115,000 in 1965, in common with dramatic increases in Ilford, Hornchurch and, to a lesser degree, Chingford. This change was a consequence of the war when people moved away from the poor, drab boroughs of Stratford, Leytonstone, Walthamstow, West Ham and East Ham. Crowley's father, who came from Whitechapel, had moved east from Stratford after 1945. See Nikolaus Pevsner, *The Buildings of England: Essex*, Harmondsworth, Penguin Books, 1965 (second edition), p.18.

7. His contemporaries included Richard Deacon and Andrezj Klimowski in the sculpture department and Brian James, Colin McDonald, Michael Major and David Wiseman on the painting course. The sculptor Bill Woodrow was in the year above.

8. Hester Westley, 'The Year of The Locked Room', *Tate*, 9 (Spring 2007), p.56.

9. Also important for Crowley was the presence on the school's staff of Robert Bell, brother of the American artist, Larry Bell, and the painter Ronnie Rees.

10. Crowley also points out the cultural legacies of Cardew and Captain Beefheart, viewing them as visionaries in the evolution of a genuinely popular culture. For instance, Cardew has been cited in the music of Sonic Youth and Beefheart was important to The Clash, the Sex Pistols, The White Stripes, the Red Hot Chili Peppers and others. (Comment to the author, summer 2008.)

11. His record of student activism at St Martin's may have marked Crowley out for the RCA's authorities, and the student clashed with Carel Weight, professor of painting since 1957, over a controversial appointment to the teaching staff.

12. Crowley asserts that 'synthetic figuration is the condition of all "self-conscious" painting', that is, painting in which the artist makes reference to the world of perceived phenomena either directly or indirectly through emphasis on its plastic values. He cites Fernand Léger as an example of an artist working, especially after 1919, with a synthetic form of figuration. (Comment to the author, May 2008.)

13. John Golding, 'Introduction', *Visions of the Modern*, Thames and Hudson, London, 1994, p.8. A postgraduate student at the Courtauld Institute of Art, Golding in that year visited the large exhibition of Cubist painting in Paris; responding immediately to the work, he directed his research towards Cubism.

14. Timothy Hyman, 'After Léger', *London Magazine*, XVII, 6 (December 1977), p.63.

15. Crowley showed alongside Woodrow at the Museum of Modern Art, Oxford, in concurrent solo exhibitions in May-June 1983. John McEwen wrote that the combination made 'a strong and visually sympathetic double bill...' (John McEwen, 'Influenced', *Spectator*, 30 July 1983.) Waldemar Januszczak remarked that 'Bill Woodrow's sculpture can be compared with Graham Crowley's paintings on several counts. He also uses ordinary subject matter and he too creates extraordinary new identities for them.' (Waldemar Januszczak, 'A nasty shock for the still-life', *Guardian*, 10 June 1983, p.14.)

16. Peter de Francia, *Painters on Painting: Peter de Francia on Léger's "The Great Parade"*, Cassell, London, 1969, p.17.

17. John Golding, 'Léger and the Heroism of Modern Life', *Léger and Purist Paris* (exhibition catalogue), Tate Gallery, London, 1970, p.10.

18. With these likeminded contemporaries and a few others, such as Richard Miller and David Wiseman, Crowley was involved with the 'Fine Art Society' at the RCA in 1972. With its objective of treating painting as a hobby, the group was partly conceived as a light satire on the tenor of Weight's regime and partly as a deadly serious forum for ideas. Guest speakers included Golding and Richard Wollheim (1923-2003), the philosopher who brought an empirical edge to the interpretation of painting and to whom is attributed the first use of the term 'minimal' about art (in 1965).

19. Crowley admired The Clash, the band that was part of the original wave of punk rock and which also borrowed from other genres, such as reggae, ska, dub, funk, rap and rockabilly in the creation of its distinctive, hybrid sound.

20. William Feaver, 'The Seal of Approval', *Observer*, 15 July 1979, reviewing *Style in the Seventies* at Arnolfini, Bristol, an exhibition of recent British painting organised by the art journal, *Artscribe*.

21. Graham Crowley in a public lecture 'The Moores and me' (recording), Walker Art Gallery, Liverpool, 31 October 2006.

22. Crowley's exhibitions in these years attracted particularly supportive critical reviewing from William Feaver in the *Observer* and John McEwen in the *Sunday Times* and *Spectator*. From other newspaper critics, Crowley received a generally encouraging passage. Waldemar Januszczak wrote 'What an excellent artist Graham Crowley is' in the *Guardian*, 16 October 1984, and described the artist as Lucian Freud's 'young heir' in *Flash Art*, January 1985.

23. Graham Crowley quoted in Robert Ayres, 'Graham Crowley', *Artscribe*, 40 (April 1983), p.14.

24. John Roberts, *Aspects*, op. cit.

25. Graham Crowley quoted in 'Under the Shadow', *FIRES*, London, 1 (summer 1986), p.34.

26. An unexpected parallel may be found in Sigmar Polke's choice of household fabrics as painting surfaces from the late 1960s which ensured that domestic reality intruded on the

viewer's awareness within the rarefied environment of the gallery.

27. Crowley drew on his perception of his own childhood in portraying 'home' as a potentially 'fearful and violent place'. (Comment to the author, summer 2008.)

28. '"Open Attitudes," Museum of Modern Art, Oxford; Tate Gallery Extension, London', *Artforum*, November 1979.

29. William Feaver, 'The Liverpool Lottery', Observer, 30 November 1980.

30. William Feaver, Orchard Gallery, op. cit. p.9.

31. William Feaver, '81 for the road', *Observer*, 12 April 1981, reviewing *Tolly Cobbold*.

32. Richard Wollheim, *Painting as an Art*, Thames and Hudson, London, 1987.

33. Marco Livingstone, 'Graham Crowley' in *A Proper Study* (exhibition catalogue), British Council, London, 1984

34. As will be seen, these paintings were made at a time of social upheaval and political division in Britain. The strict monetarist policies of Margaret Thatcher's first government (1979-83) had brought about high levels of unemployment and high rates of . interest that discouraged borrowing and made many traditional manufacturing industries uneconomic. Civil unrest had broken out on the streets of large cities such as Bristol, Liverpool and London in these years and government decisions to retake the Falkland Islands by force after the Argentinian invasion in 1982 and to ally the country closely with US President Ronald Reagan's escalation of the nuclear and conventional arms race with the Soviet Union polarised British public opinion like seldom before in peacetime.

35. Richard Wollheim quoted by Arthur C. Danto, 'Obituary: Richard Wollheim', *Guardian*, 5 November 2003.

36. William Feaver, 'Comic-strip heroes', *Observer*, 19 July 1987, reviewing the Comic Iconoclasm exhibition at the Institute of Contemporary Arts, London.

37. Marco Livingstone, introductory essay in *Graham Crowley: Home Comforts* (exhibition catalogue), Museum of Modern Art, Oxford, 1984, p.6.

38. Marco Livingstone, *British Figurative painters of the '80s I*, Kyoto Shoin International, Kyoto, Japan, 1989, unpag. The book, a volume in the part-work *Art Random*, featured Crowley, Tony Bevan, Stephen Farthing and Lisa Milroy. Livingstone included Milroy in his comment quoted here.

39. William Feaver, foreword to *Graham Crowley: In Living Memory* (exhibition catalogue), Orchard Gallery, Derry, 1988, p.10.

40. Marco Livingstone, Oxford, p.11.

41. Crowley married Sally Townshend in 1978. Their first son, Robin, was born in 1982 and their second, Pearce, in 1985.

42. *Clampdown* appeared as a track on *London Calling* (1979) by The Clash. In the general election of 1979 the Conservative party supplanted the Labour government weakened in popular opinion by industrial strife with trades unions that culminated in the 'Winter of Discontent' in 1978-9.

43. The theme of open windows and reflections in glass recur in these years, from *Reflections* and… *with winds light to moderate*, both 1983, to the *In Living Memory* series in 1986. The idea of multiple forms of engagement in a painting through the use of reflections that place objects or action in a different space or in a notional space in front of the painting appeared in the work of Alan Miller from about 1981. See *Alan Miller:*

*Selected Paintings 1974-1984* (exhibition catalogue), Ikon Gallery, Birmingham, 1984. The text in this publication records a conversation between Miller, Crowley and the painter Stephen Farthing.

44. Graham Crowley quoted in *FIRES*, op. cit., p.34.

45. Marco Livingstone, '"In Every Dream Home a Heartache"', *Art & Design* 4, 9-10 (November 1988), p.69.

46. Crowley's first solo exhibition took place at the Hoya Gallery in London in November-December 1973 while he was a postgraduate student. (Henry Mundy and John Plumb had concurrent shows.) His next London one-man show occurred at Ian Birksted's Hampstead gallery in May-June 1979. Between 1980 and 1987, Crowley was showing regularly. After the AIR Gallery exhibition, the most important solo presentation took place at the Museum of Modern, Oxford, in May-July 1983 (then touring to St Paul's Gallery, Leeds, and New 57 Gallery, Edinburgh), when 15 paintings, 17 drawings and three studies for murals were exhibited. The show followed Crowley's residency at Oxford University in 1982-3.

47. Richard Cork, 'Art and the London Underground: From Marinetti to Paolozzi', *Eduardo Paolozzi Underground*, Weidenfeld and Nicolson, London, 1986, p.34.

48. Introduction, *Holborn Station: Open Competition for Artists* (competition brief), London Transport, nd (1980), unpag.

49. Richard Cork, 'Art Underground', *Evening Standard*, 7 August 1980, reprinted in R. Cork, *New Spirit, New Sculpture, New Money: Art in the 1980s*, Yale University Press, London, 2003, p.357.

50. Ibid. The competition prize-winners were displayed in a special exhibition at the Whitechapel Art Gallery, London, in August 1980.

51. *Holborn Station: Open Competition for Artists*, loc. cit.

52. Richard Cork, 'Inter-city dreamworld', *Evening Standard*, 1 October 1981, reprinted in R. Cork, *New Spirit, New Sculpture, New Money: Art in the 1980s*, Yale University Press, London, 2003, p.377.

53. John McEwen, 'A brush with the young masters', *Sunday Times Magazine*, 23 October 1983, p.68.

54. According to the *Observer* on 23 August 1981, the mural consumed 80 gallons of paint. It was completed in five days and Crowley was assisted by four other artists, including the sculptor Richard Deacon.

55. 'Briefing: Gallery guide', *Observer*, 27 September 1981.

56. The hospital's internal newsletter, *Brompton Bulletin*, reported that in the poll of 353 patients, staff and visitors, Crowley's bird design received 44% of votes, with his other submission, called 'Carnival', coming second with 18%. 'A minority,' the Bulletin added, 'thought none of the designs was appropriate… Interestingly quite a few staff who thought this said that they thought the designs would put patients off, but the response from patients themselves did not support this feeling of concern.' That response mentioned 'cheerful' and reassuringly restful colours and the 'open-air feeling.' (See *Brompton Bulletin*, 360 (undated).) The similarity of work's title with Alfred Hitchcock's thriller film can be safely assumed to be intentional. But the title was as far as menacing overtones reached in this work, and patients would not have been aware of the title as they awaited treatment.

57. Martin Holman, 'Where art fulfils a public function', *Parade*, Central Office of Information, London, 1984, unpag.

58. Waldemar Januszczak, 'Band-Aids for all ills', *Guardian*, 7 August 1984.

59. Waldemar Januszczak, 'A nasty shock for the still-life', *Guardian*, 10 June 1983, p.14.

60. Gaston Bachelard, *The Poetics of Space*, tr. Maria Jolas, Beacon Press, Boston, Mass., 1969, p.47. The nature of Bachelard's response to architecture has a parallel in the sensations identified by Wollheim in some modern painting. About a work by Willem de Kooning in *Painting as an Art*, Wollheim wrote that: 'The sensations that de Kooning cultivates are the most fundamental in our repertoire. They are those sensations which...bind us for ever to the elementary forms of pleasure into which they initiated us - sucking, touching, biting, excreting, retaining, smearing, sniffing, swallowing, gurgling, stroking, wetting.'

61. William Feaver, 'One True Faith', *Observer*, 22 July 1984.

62. *Night Life* was executed in five days by Crowley and his assistants who included the painters David Austen & Simon Bill.

63. William Feaver, Orchard Gallery, op. cit. p.8.

64. Ivan Albright (1897-1983) was an American painter to whom the label of magical realism was attached. With his interest from the early 1970s in Stuart Davis, Crowley's curiosity spread laterally to artists of Davis's generation. In the 1980s, overtly figurative artists like Albright and painters of 'The American Scene' attracted his attention.

65. Graham Crowley in 'A Drift', his professorial lecture as Professor of Painting at the Royal College of Art, London (video recording), 21 October 1999.

66. Brian McAvera, 'Graham Crowley', *Art Monthly*, April 1988

67. Crowley admires the exquisite craftsmanship of dedicated amateurs, and the pursuit of the talented amateur of selective dexterity is a trait that appeals to him. He said to this author that 'I am the sort of person who wants to side with people who make lighthouses out of matchsticks.' (Comment to the author, summer 2008.)

68. Crowley rejects phrases like 'polyptych' as unhelpful in modern painting. For him, they convey the ridiculous pretension that the actor Tony Hancock exhibited in his role as a talentless aspiring artist in the comedy film, *The Rebel* (1960). The word also risks comparison with other recent artists using the format for different reasons, most notably Francis Bacon.

69. *The Chambers Dictionary*, Edinburgh, 2006, p.490.

70. The concept of empathy, or *Einfuhlung* ('feeling into'), was first expounded in Germany by Robert Vischer in his treatise *Über das optische Formgefuhl: Ein Beitrag zur Aesthetik*. Early art historians, such as Heinrich Wöfflin, lost interest in the idea, but it remained in the discussion of modern architecture. See Juliet Koss, 'On the limits of empathy', *Art Bulletin*, March 2006.

71. Nigel Lawson, *The View from No. 11*, Bantam Press, London, 1992, p.279-80. Lawson was Chancellor of the Exchequer for seven years from 1983 in Margaret Thatcher's administration.

72. Margaret Thatcher in a television interview with Brian Walden, 'The Resolute Approach', *Weekend World*, London Weekend Television, 16 January 1983. Thatcher won a resounding victory, in terms of parliamentary representation, over the main opposition groups, Labour and the Alliance of Liberal and Social Democratic parties. Labour had pledged to leave the EEC, abolish the House of Lords and abandon Britain's nuclear deterrent by cancelling the Trident missile development and removing American Cruise missiles from British bases.

73. *Westminster Gazette*, London, 1873.

74. Clement Greenberg, 'Modernist Painting' (1965), reprinted in Gregory Battcock (ed.), *The New Art: A Critical Anthology*, E.P. Dutton, New York, 1973, p.70.

75. Aldous Huxley, *Ends and Means: An Enquiry into the Nature of Ideals and into the Methods employed for their Realization*, Chatto and Windus, London, 1937, p.272. Crowley admires this collection of essays, written by the pacifist as war became a likelihood on subjects ranging from 'The Nature of Explanation' and 'Centralisation and Decentralisation' to 'Beliefs', 'Ethics' and 'Individual Work for Reform'. Crowley especially values Huxley's essay on education.

76. The Institute had evolved from the merger between several colleges in higher and further education, including Cardiff College of Art.

77. The title is a play on the title of the successful American independent horror film *The Texas Chainsaw Massacre* (1974). The plot concerns a group of friends whose road trip in rural Texas deteriorates into gruesome tragedy when they encounter a family of cannibals. The film was highly influential and spawned several sequels, the first appearing in 1986.

78. David Lee, 'The state of modern art', *The Times*, 16 June 1988.

79. Margaret Thatcher quoted in Douglas Keay, 'Aids, education and the year 2000' (interview), *Woman's Own*, 31 October 1987, p.9.

80. William Feaver, 'Congratulations to a blotter on the landscape', *Observer*, 24 October 1993.

81. Graham Crowley, *John Moores Liverpool Exhibition 18* (exhibition catalogue), Walker Art Gallery, Liverpool, 1993, unpag.

82. Graham Crowley quoted in Deanna Petherbridge, 'The Riverscape project: art and regeneration', *Riverscape: four international artist residencies, River Tees, Cleveland*, Cleveland Arts, Middlesbrough, nd [1993], p.11.

83. 'Battling with the elements for the sake of art in Teeside', *Darlington and Stockton Times*, 2 May 1992.

84. Deanna Petherbridge, op. cit., p.5. The brief to the artists, who came from Britain, India, Japan and Poland, was 'to respond visually to the River Tees and its relationship with industry, the community and leisure through the medium of drawing.'

85. Ibid.

86. *Darlington and Stockton Times*, op. cit.

87. Petherbridge mentions that one reference for Crowley at this time at work by Alexander Cozens (1717?-86). In his remarkable drawing manual (1785), Cozens who proposed that landscape composition could be simulated out of random blots, an idea also attributed to Leonardo da Vinci. Crowley was less detached from the subject, but Cozens' practice assisted with objectifying the image. Deanna Petherbridge, op. cit., p.12.

88. Many local people opposed the plant, commissioned in 1983, as did Greenpeace, the environmental lobby group. Nuclear power was promoted as a cheap and efficient method to diversify sources of electricity for general use but by the early 1990s, politicians had decided it was neither, largely because of the huge cost of decommissioning a power station. Nigel Lawson was secretary of state for energy in 1981-3 and Chancellor of the Exchequer when the electricity industry was privatised in 1989, so see Nigel Lawson, op. cit., pp.166-70.

89. Vera Baird, MP for Redcar, in her maiden speech to the House of Commons, *Hansard*, London, 9 July 2001, column 265.

90. Graham Crowley quoted in William Feaver, 'If you go down to the woods…', *Observer Magazine*, 1 September 1991.

91. Ibid.

92. Barrell studied the work of three painters, Thomas Gainsborough George Morland and John Constable, and the radical change in their depiction of country life as the conventions of the classical or theatrical pastoral eased and they could offer a portrayal of what life was really like, or was thought to be like. (See John Barrell, *The Dark Side of the Landscape: The rural poor in English painting 1740-1840*, Cambridge University Press, 1980.) In similar vein, Crowley's interest in the paintings of his younger contemporary, Julian Perry, is based partly on Perry's meticulous craftsmanship and partly on the knowingness of his unsentimental treatments of present-day east London which refer to favourite painters like Rubens, Casper David Friedrich and Constable.

93. Another painting in the exhibition was titled *Boys' Own*.

94. The playwright, Dennis Potter, grew up in a working class community in the Forest of Dean, as Feaver points out. The coincidence is informative for the convergence in Potter's and Crowley's views. In his interview with Potter, Melvyn Bragg asked him about his childhood which had inspired Potter's 1979 bitter-sweet television play, *Blue Remembered Hills*. The protagonists are children (played by adults) playing in the Forest in summer 1943. Despite seeming frivolous at first, the play actually reflects on human capability for brutality, especially in children. Bragg said 'we've both been through that [rural upbringing], and we know that things were wrong – awful and terrible and so on – but there's a glow there. Is it a glow because you're a middle-aged man looking back?' In his reply, Potter said that 'childhood…is full to the brim of fear, horror, excitement, joy, boredom, love, anxiety.' Interview originally broadcast by Channel 4 television, 5 April 1994.

95. Feaver, *Observer Magazine*, op. cit.

96. The biggest demonstration in Britain of grief spontaneously commemorated with flowers occurred with the death in a traffic accident in Paris of Diana, Princess of Wales, in August 1997. In the days that followed, an estimated one million bouquets were left by members of the public outside Kensington Palace and more outside Buckingham Palace.

97. By working in one colour only, Crowley was also making reference to the late modernist convention exemplified by Yves Klein and, more particularly, Robert Ryman, and to the legacy that can be traced through Barnett Newman to Piet Mondrian and Kasimir Malevich, which had become critical orthodoxy by the late 1960s.

98. John McEwen, 'The poetic beauty of an unhinged castle gate', *Sunday Telegraph*, 8 June 1997.

99. A concomitant is the whirl of stars circling the head of the inebriated Donald Duck in *The Drunken Duck* (2004).

100. Andrew Lambirth, *Graham Crowley: The Flower Show* (exhibition catalogue), The Lamont Gallery, London, 1998, p.4

101. E. Havercamp Begemann, *Hercules Seghers*, J.M. Meulenhoff, Amsterdam, 1968, p.19.

102. Crowley responds enthusiastically to the changing role of the Dutch painter in the seventeenth century. An artist of Segers's generation would have been institutionally bound to other craftsmen in his hometown's Guild of St Luke. These trades would have included glassmakers, faïenciers, tapestry-makers, embroiderers, engravers, sculptors, scabbard makers, booksellers. Moreover, artists were often the children of craftsmen; Ruisdael's father was a frame-maker. Thus, artists were imbued with craft without any connotation attaching to that heritage of the rote, mechanical or conservative. See Svetlana Alpers, *The Art of Describing: Dutch art in the seventeenth century*, John Murray, London, 1983, p.112.

103. Ruisdael's *Grainfields* (1660s) in the Metropolitan Museum of Art, New York, recorded a noteworthy topographic feature for the observer of the time; a painting of wheat fields in Museum Boymans van-Beuningen, Rotterdam, may have had similar resonance. Industry was important to a new republic dependent on trade and it is possible to attribute the deliberate selection of elements for contemplation to Ruisdael.

104. Graham Crowley, artist's statement, *London Underground* (exhibition catalogue), Sungkok Art Museum, Seoul, South Korea, 2001, unpag.

105. The British Council circulated an exhibition to venues abroad in 2000 called *Landscape*. In her catalogue introduction Andrea Rose, the council's director of visual arts, explained that the theme had been chosen because 'it is an area rich in invention among younger artists, brought up for the most part in cities, and coming to the countryside without the baggage of sentiment and psychological attachment'. Most of the 20 selected artists had been born in the mid-1960s and included the painters Patrick Brill (Bob and Roberta Smith), Keith Coventry, Peter Doig, Mariele Neudecker, Paul Noble, David Rayson, Michael Raedecker and Paul Winstanley. See Ann Gallagher and Patrick Keiller, *Landscape* (exhibition catalogue), British Council, London, 2000.

106. Graham Crowley, artist's statement, *John Moores 23* (exhibition catalogue), Walker Art Gallery, Liverpool, 2004, p.50.

107. Crowley admits a close affinity with the graphic styles of Gustave Doré, Thomas Bewick and Samuel Palmer.

108. Another source was his work on paper with pen and wash. His drawings had kept the bold immediacy he achieved with charcoal in the 1980s.

109. John McEwen, *Sunday Telegraph*, op. cit.

110. William Feaver, 'Emigrating to avoid your critics seems a little extreme', *Observer*, 1 June 1997.

111. Graham Crowley, artist's statement, *John Moores 23*, op. cit.

112. The question was posed to the artist at a talk at West Cork Arts Centre, Skibbereen. Undated recording, *c*.2006.

1 · **Canvey** · 1976
Acrylic on canvas 120 x 120 cm
The artist

2 · **Untitled** · 1976
Chalk and acrylic gel on canvas 50 x 42 cm
The artist

3 · **Cuff** · 1976
Chalk with canvas collage on canvas 153 x 92 cm
The artist

4 · **Untitled** · 1976
Compressed charcoal on paper 30 x 21 cm
The artist

5 · **K's Spagna** · 1977
Acrylic on canvas 153 x 92 cm
The artist

6 · **Head (2)** · 1977
Acrylic on canvas 153 x 92 cm
The artist

7 · **Study (1)** · 1978
Acrylic on canvas 50 x 42 cm
The artist

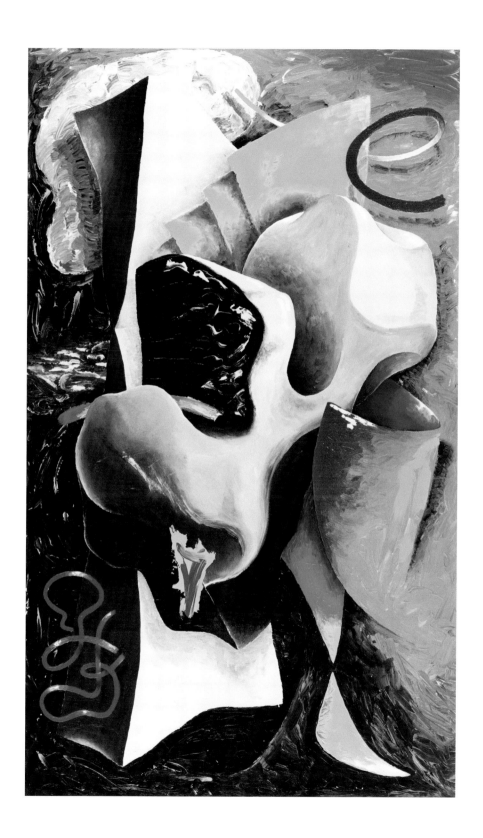

8 · **Phlogiston (3)** · 1979
Acrylic on canvas 153 x 92 cm
The artist

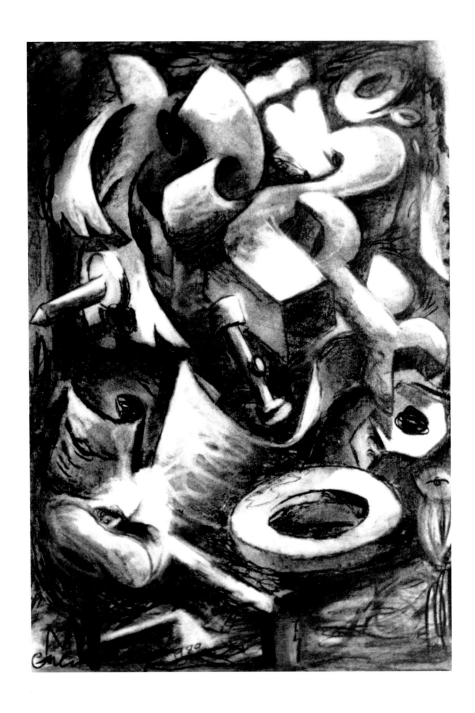

9 · **Untitled** · 1980
Compressed charcoal on paper 102 x 71 cm
The artist

10 · **So and Sew** · 1980

Oil on canvas 137 x 114 cm

Private collection

11 · **Kitchen Life** · 1981

Oil on canvas 152.5 x 122 cm

The artist

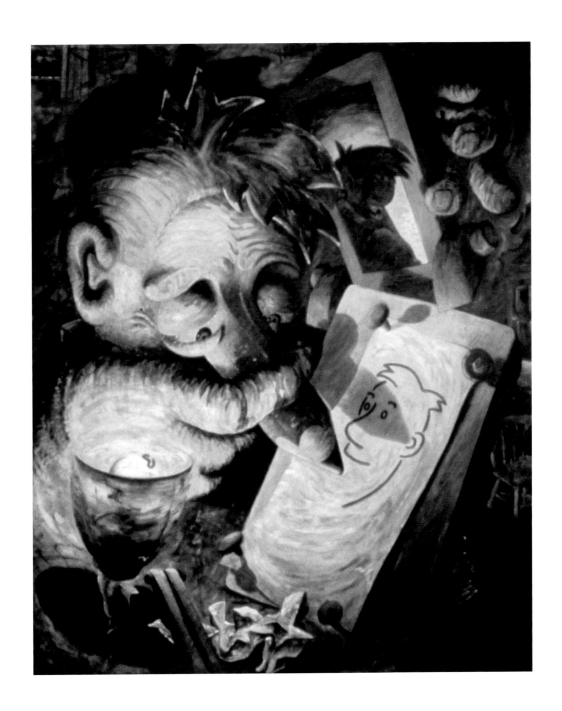

12 · **3B** · 1982
Oil on canvas 137 x 114 cm
Basildon Arts Trust, Essex

13 · **The Clampdown** · 1982
Oil on canvas 153 x 122 cm
Private collection

14 · **Spider with Mushroom Soup** · 1982

Oil on canvas 122 x 92 cm

Arts Council Collection, Southbank Centre, London

15 · **The Living Room** · 1983
Oil on canvas 176 x 152 cm
Private collection

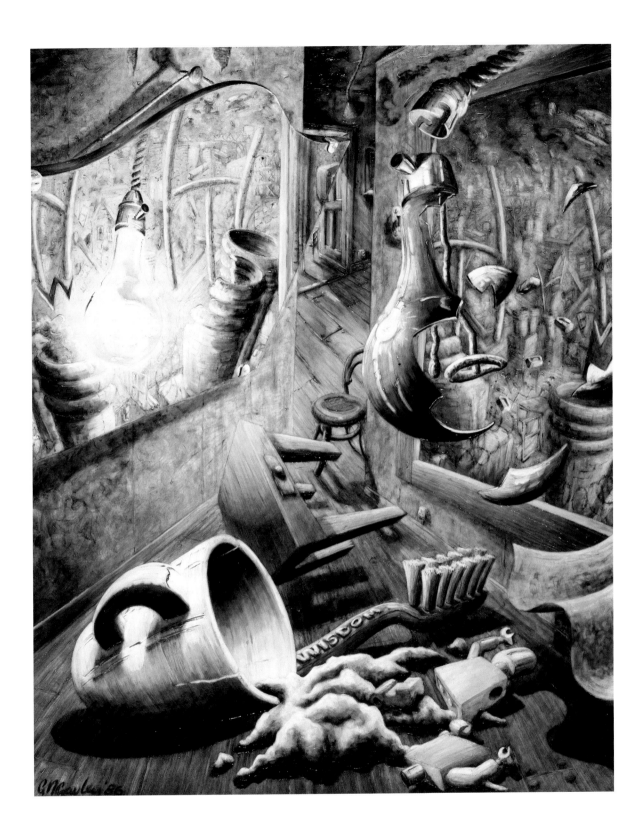

16 · **Light Fiction** · 1986

Oil on canvas 213 x 162 cm

Destroyed

17 · **In Living Memory** · 1986
Oil on canvas, 6 panels, overall dimensions 203 x 750 cm
Private collection

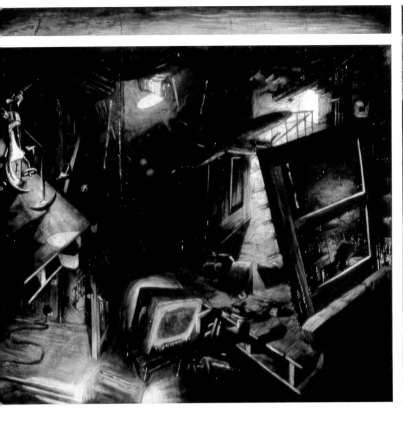

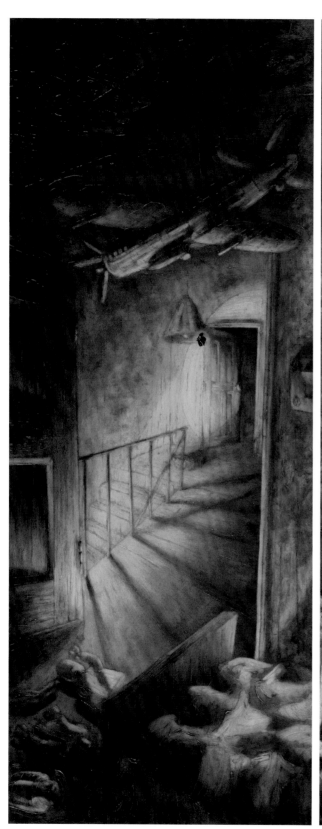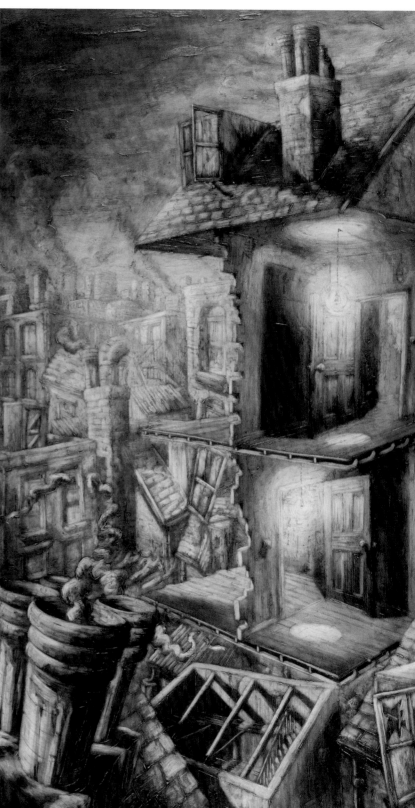

18 · **Peripheral Vision** · 1987

Oil on canvas, 3 panels, overall dimensions 193 x 340 cm

The artist

19 · **The Chain Store** · 1987

Oil on canvas 160 x 240 cm

Collection of Middlesbrough Institute of Modern Art

20 · **Flower Arranging (1)** · 1988/92

Oil on canvas 178 x 152 cm

The artist

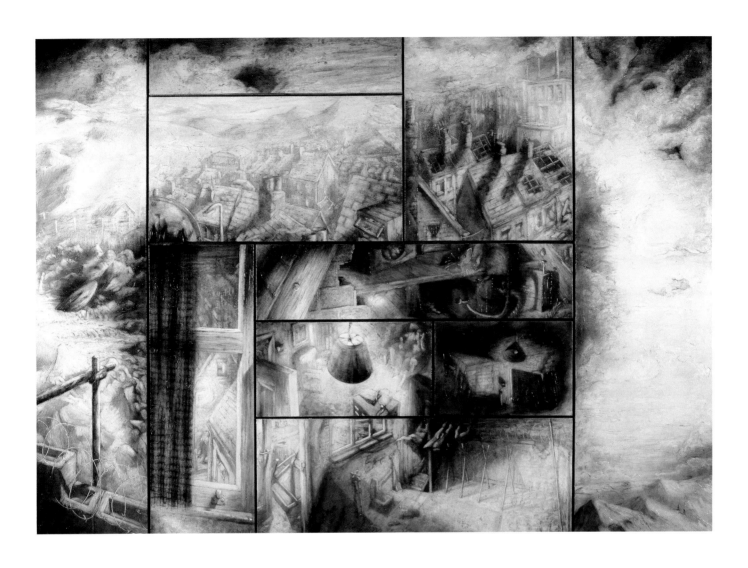

21 · **Law and Order** · 1988

Oil on canvas, 10 panels, overall dimensions 175 x 242.5 cm

Private collection

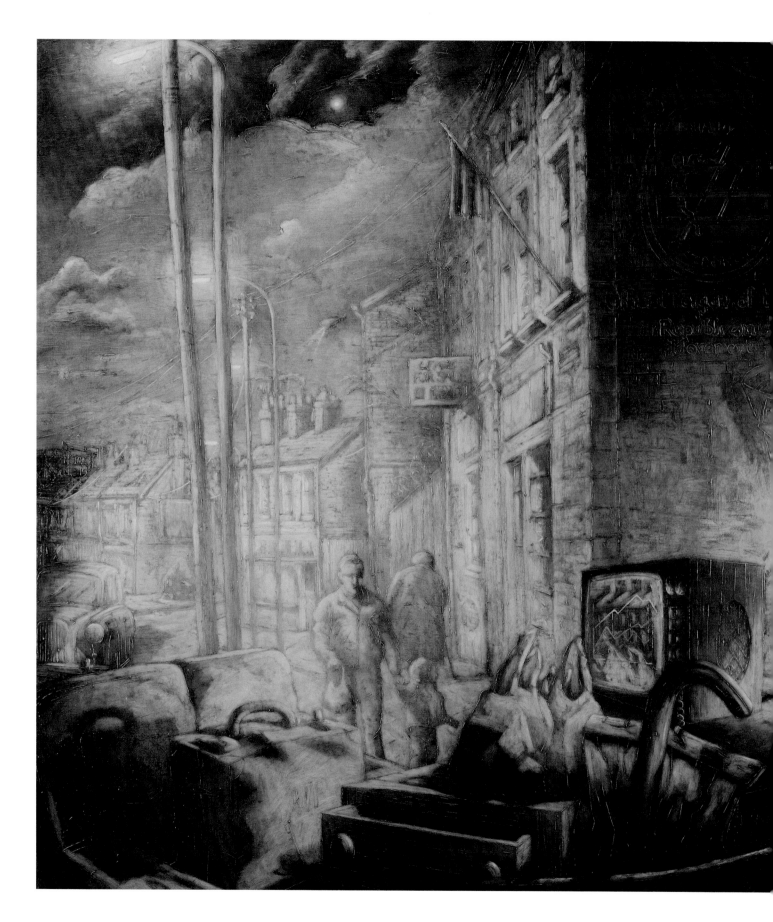

22 · **Eviction** · 1988
Oil on canvas 162.5 x 203 cm
The artist

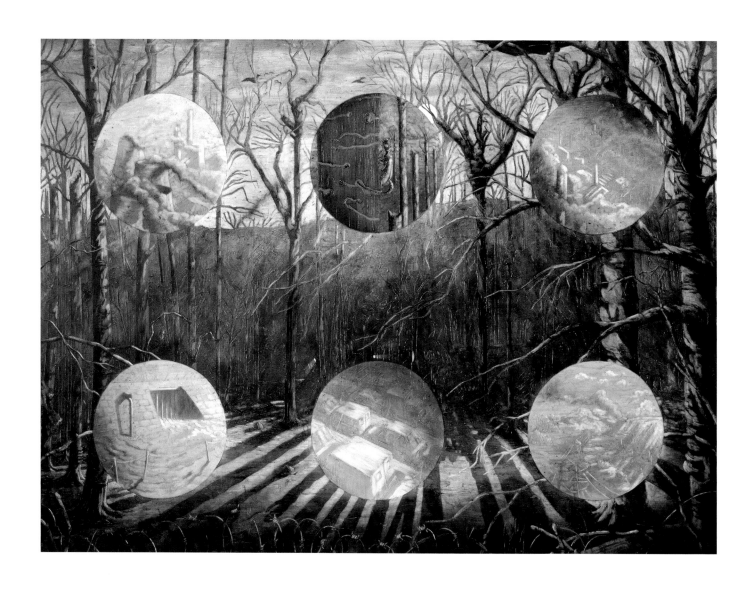

23 · **Encyclopædia** · 1991
Oil on canvas 142 x 193 cm
The artist

24 · **Suspicion** · 1991
Oil on canvas 114 x 137 cm
The artist

25 · **Power Station** · 1991
Compressed charcoal with pen and wash, collage, on paper 84 x 114 cm
The artist

26 · **Small Black City** · 1991

Oil on board 30 x 41 cm

The artist

27 · **Pontypool** · 1991
Oil on canvas 160 x 127 cm
The artist

28 · **The River Tees at Yarm** · 1992

Compressed charcoal, pencil and ink on paper collage 67 x 54 cm

Private collection

29 · **No Such Thing** · 1993
Oil on canvas 168 x 240 cm
The artist

30 · **Flower Arranging (5)** · 1997

Oil on canvas 137 x 107 cm

Private collection

31 · **Flower Arranging (6)** · 1998

Oil on canvas 178 x 152 cm

The artist

32 · **Flower Arranging (7)** · 1998
Compressed charcoal and oil on canvas 122 x 92 cm
The artist

33 · **Small Flower Painting (1)** · 1998

Oil on canvas 51 x 40.5 cm

Private collection

34 · **Untitled** · 2000
Oil on board 30 x 41 cm
Private collection

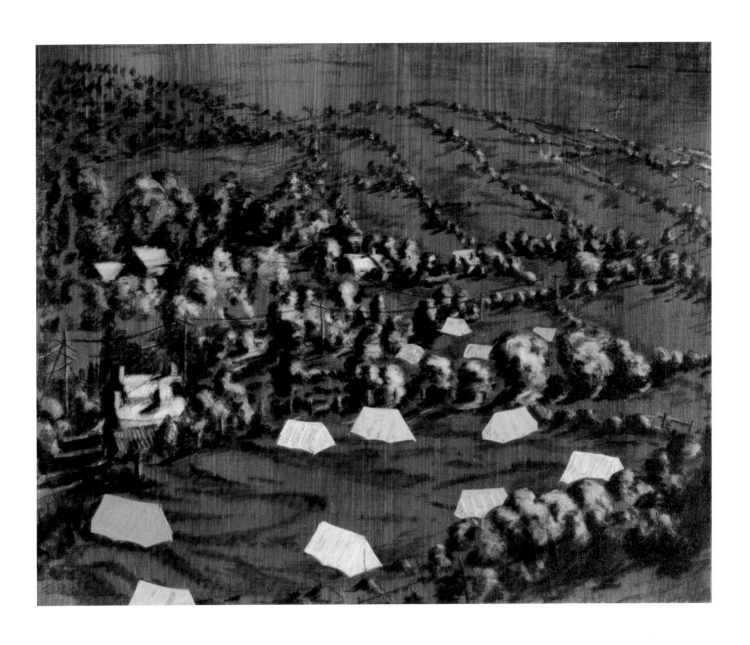

35 · **Tents** · 2000
Oil on canvas 40 × 51 cm
Private collection

36 · **Crystal Palace** · 2000
Oil on board  30 x 41 cm
Private collection

37 · **Red Landscape** · 2001
Oil on canvas 114 x 137 cm
The artist

38 · **Crowley's (Killorgiln)** · 2002
Oil on canvas 61 x 81.5 cm
The artist

39 · **Blue Street** · 2002
Oil on canvas 92 x 114 cm
Private collection

40 · **Red Day (Valentia)** · 2002
Oil on canvas 61 x 71 cm
Private collection

41 · **Red Day** · 2002
Oil on canvas 114 x 137 cm
The artist

42 · **Green Day** · 2002
Oil on canvas 40 x 51 cm
The artist

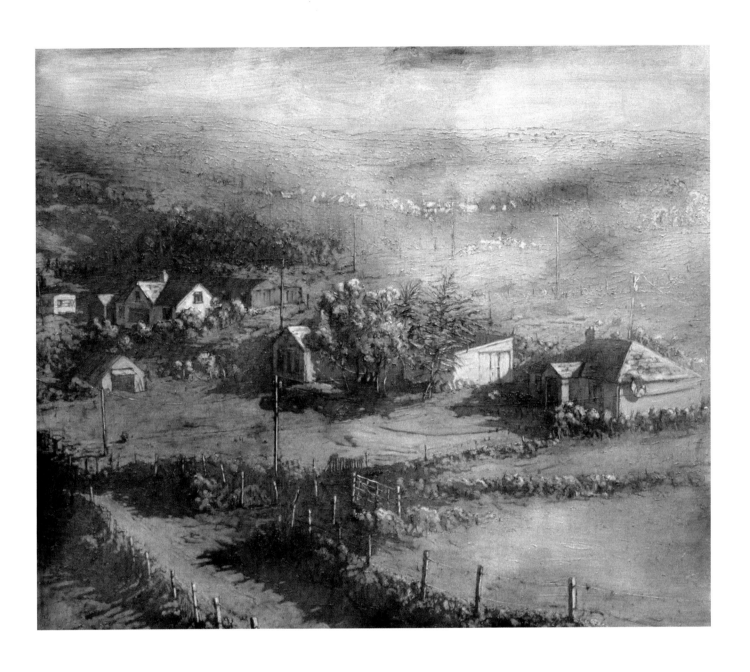

43 · **Morning** · 2002
Oil on canvas 135 x 158 cm
Private collection

44 · **Heart** · 2002
Oil on canvas 114 x 137 cm
The artist

45 · **Moon** · 2002
Oil on canvas 114 x 137 cm
Private collection

46 · **One Day** · 2002
Oil on canvas 114 x 137 cm
The artist

47 · **Red Terrace** · 2003
Oil on canvas 114 x 137 cm
The artist

48 · **Houses (Union Hall)** · 2003
Oil on canvas 61 x 71 cm
Private collection

49 · **Green Lane (2)** · 2004
Oil on canvas 61 x 71 cm
Private collection

50 · **Houses at Myross** · 2004
Oil on canvas 91 x 114 cm
Private collection

51 · **Clouds over Farranconor** · 2004
Oil on canvas 91 x 114 cm
Private collection

52 · **Blue Homes** · 2004

Oil on canvas 61 x 71 cm

The artist

53 · **Pink Evening** · 2005
Oil on canvas 40 x 51 cm
Private collection

54 · **Red Reflection** · 2005
Oil on canvas 152.5 x 178 cm
The artist

55 · **Blue Reflection** · 2007
Oil on canvas 114 x 137 cm
The artist

56 · **Back o'Leap** · 2007
Oil on canvas 92 x 114 cm
The artist

57 · **Untitled** · 2007
Oil on canvas 92 x 114 cm
The artist

58 · **Farm on the Sheep's Head** · 2007
Oil on canvas 114 x 137 cm
Private collection

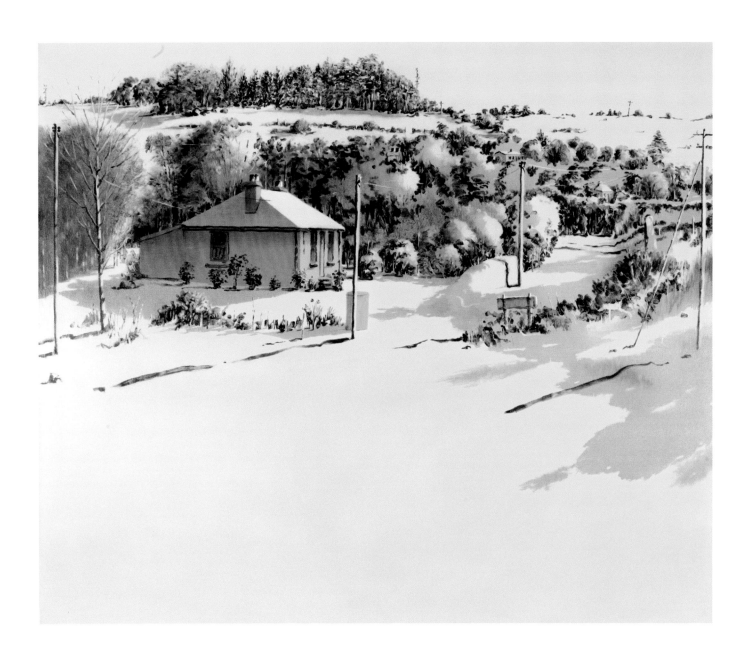

59 · **House near Drinagh** · 2007
Oil on canvas 114 x 137 cm
The artist

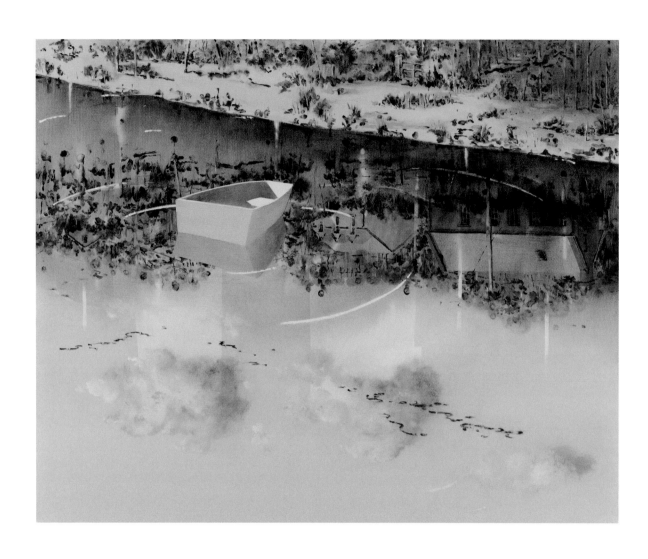

60 · **Blue Drift** · 2009
Oil on canvas 92 x 114 cm
The artist

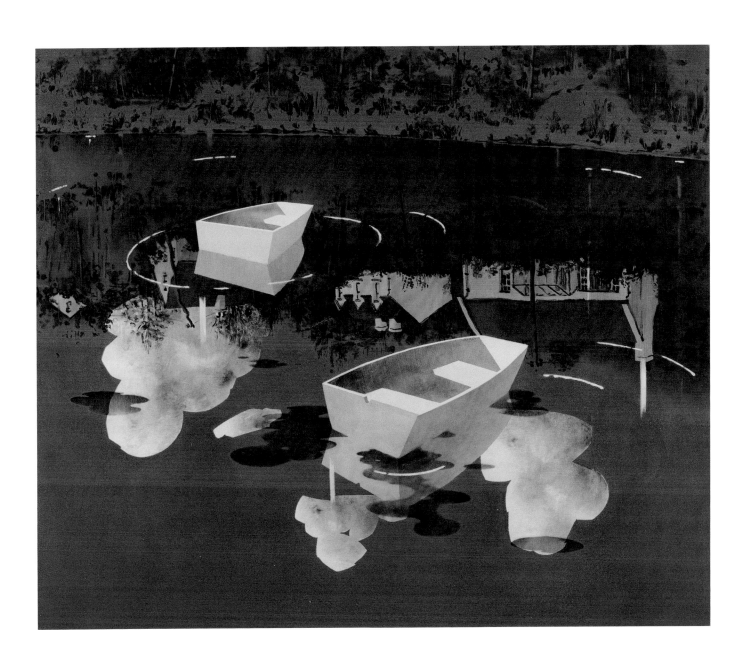

61 · **Red Drift** · 2009
Oil on canvas 114 x 137 cm
The artist

# Chronology

1950 Born in Romford, Essex. Father is a toolmaker and electro-mechanical engineer with Kelvin & Hughes which specialises in marine navigational systems. Brother, Stephen, born in 1952.

1961-8 Attends Rayleigh Sweyne Technical and Grammar School after parents turn down scholarship to King Edward VI Grammar School, Chelmsford. Passes 'A' levels in art, economics and mathematics. Writes and performs in school stage reviews. Hobbies include drawing and model-making, animated cartoons and comic strips.

1968-72 Attends St. Martin's School of Art, London, progressing from foundation to undergraduate diploma course in painting in 1969. Tutors include Gillian Ayres and Harry Mundy; meets Raymond Durgnat and Michael Williams. Fellow students include Richard Deacon, Craigie Horsfield, Andrzej Klimowski, Richard Miller and David Wiseman. Graduates in 1972. Vice-president of the school's students' union and active in the London Art Schools Alliance. Writes satirical plays and performs them with Bobby Baker (*Mystery on the Rebound*) and Peter Eddleston, Stephen Farthing, Wiseman and other contemporaries (*The Revenge of Doctor X*).

1969 Makes first visit to Ireland.

1972-5 Studies painting at the Royal College of Art (RCA), London; awarded MA in 1975. Meets fellow student Michael Major and tutors include Peter de Francia, John Golding and Alan Miller. Involved with the 'Fine Art Society' set up by fellow students; speakers invited to meetings include Richard Wollheim. Visits Italy and France, including Musée Léger at Biot.

1973 First one-man exhibition, at the Hoya Gallery, London.

1976 Selected for *John Moores Liverpool Exhibition*; selected again in 1980, 1982, 1985, 1987, 1993, 2004 and 2006. Arts Council of Great Britain (ACGB) purchases *Tug* (1975) from the 1976 show. Named joint second prize-winner in 1987 for *The Poetics of Space* (1986) and prize-winner in 2006 for *Red Reflection* (2005). Receives ACGB minor ward in 1976, with a major award in 1977.

1978 Marries Sally Townshend, a contemporary at the RCA studying environmental design. First son, Robin, born in 1982, and second, Pearce, in 1985.

1978-85 Visiting lecturer in painting, RCA. Also visiting lectureships at Winchester School of Art (1978-82) and at Goldsmiths' College, University of London (1984-6). Occupies studio in Baldwin's Gardens, off Gray's Inn Road, London, until early 1980s.

1980 Returns to painting after self-imposed break of about a year.

1981 (March) Visits Italy. (October) Inauguration of *Ticket on the Move*, his first major public art commission, at the Pitt and Scott building, London. Other public commissions follow, including *The Birds* at the Brompton Hospital, London (1982), and *Four Seasons* at Chandler's Ford public library, Hampshire (1983).

1982-3 Artist-in-residence to Oxford University and visiting fellow of St Edmund Hall, Oxford. One-man exhibition, *Home Comforts*, opens in May 1983 at Museum of Modern Art, Oxford, to complete the residency.

1983 Prize-winner, *Tolly Cobbold-Eastern Arts, Fourth National Exhibition*, with *3B* (1982).

1982-8 Member of the Fine Art Faculty, British School at Rome.

1983-6 Lives and works in south-east London.

1984 First one-man show with Edward Totah Gallery, London. Other shows with this art dealer follow in 1987, 1989 and 1991, and in 1986 at Totah-Stelling Gallery, New York. Delivers lecture 'The Importance of Being Subversive' in programme organised by the Ashmolean Museum, Oxford.

1985-9 Member of the advisory board, Institute of Contemporary Arts (ICA), London.

1986 Included in *Comic Iconoclasm* at the ICA.

1986-9 Senior fellow in painting, South Glamorgan Institute of Higher Education, Cardiff.

1987-8 Member of the National Advisory Board fine art working committee of the Department of Education and Science.

1989 Family moves to cottage in Staunton in the Forest of Dean, Gloucestershire.

1990 Selected for the *Summer Exhibition*, Royal Academy of Arts, London. Shows again in 1991 and 1992.

1991 Selected for *Riverscape*, the international drawing residency for the River Tees, working in Hartlepool, Langbaurgh, Middlesbrough and Stockton during the 18-month project.

1992 Returns to London.

1993-4 One year appointment as tutor in painting, Kingston University.

1994 Receives first prize in the *The First John Jones Open*, selected by Prunella Clough and Andrew Lambirth, for *Flower Arranging (1)* (1988/92). Buys house in Skibbereen, West Cork, Ireland, where spends vacations. On retirement from teaching in 2006 moves permanently to Skibbereen.

1994-5 Artist-in-residence at Dulwich Picture Gallery, London. Commissioned by Stephen Stuart-Smith to illustrate *The Mortmere Stories* by Christopher Isherwood and Edward Upward for Enitharmon Press.

1995 Commissioned by Richard Appignanesi to illustrate *Marquis de Sade for Beginners*, written by Stuart Hood in the series by Icon Books of graphic guides using comic-strip format. Prize-winner, *27e Festival international de la peinture*, Cagnes-sur-Mer, France.

1995-6 Tutor, Drawing Studio, RCA.

1996-8 Head of Fine Art, City and Guilds of London Art School, London.

1998-2006 Professor of Painting, RCA, succeeding Paul Huxley.

2007 Chairs panel of judges for the *Jerwood Contemporary Painters* exhibition, London.

2008 Initiates debate on fine art in British higher education which is pursued by the art periodical, *Art Monthly*. Member of the jury for the twenty-fifth *John Moores Liverpool Exhibition*.

2009 Lives and works in West Cork.

Graham Crowley (left) and Bobby Baker in 'Mystery on the Rebound', a play written by Crowley about an amateur dramatic society that performs a mystery thriller, 1971.

The artist with his sons, Robin and Pearce, in the studio at Upland Road, London, 1986.

The artist on the TT course, Isle of Man, 2007.

# Exhibitions

*An asterisk denotes a publication*

**One-man exhibitions**
1973 Hoya Gallery, London
1978 *Paintings and drawings*, Newcastle upon Tyne Polytechnic Art Gallery*
1979 Ian Birksted Gallery, London
1982 *Paintings and drawings*, AIR Gallery, London*
1983 *Home Comforts*, Museum of Modern Art, Oxford (touring to St Paul's Gallery, Leeds, New 57 Gallery, Edinburgh, and Darlington Arts Centre)*
1984 *Reflections*, Riverside Studios, London
*Night Life: a new project*, Institute of Contemporary Arts, London
*Table Manners*, Edward Totah Gallery, London, and Anne Berthoud Gallery, London
1986 *Domestic Crisis*, Totah-Stelling Gallery, New York
1987 *In Living Memory*, Orchard Gallery, Derry (touring to Crawford Municipal Gallery, Cork; Chapter, Cardiff; Arts Council Gallery, Belfast)*
1989 *More paintings about speculating and flower arranging*, Edward Totah Gallery, London
1990 *Ballads and Folksongs: Paintings 1981-9*, Howard Gardens Gallery, Cardiff*
1991 *Somewhere Else*, Edward Totah Gallery, London*
1992 *Northern Seen: Graham Crowley*, Northern Centre for Contemporary Art, Sunderland*
1993 Atkinson Gallery, Street, Somerset
1995 *The Last Decade: paintings and drawings*, Lamont Gallery, London
Warrens Boat House, Castletownshend, Ireland
1997 *Rineen*, Lamont Gallery, London
1998 *The Flower Show*, Lamont Gallery, London*
1999 *A Drift*, Royal College of Art, London
2001 *Familiar Ground*, Beaux Arts, London*
2002 *Are you serious?*, Wolsey Art Gallery, Christchurch Mansion, Ipswich
2003 Beaux Arts, London*
2005 Beaux Arts, London*
2006 *Paintings*, Bay Art, Cardiff
*New Paintings*, Beaux Arts, Bath
2008 West Cork Arts Centre, Skibbereen, Ireland

**Selected group exhibitions**
1970 *Stowells Trophy 1970-71*, FBA Galleries, London
1976, 1980, 1983, 1985, 1987, 1993, 2004, 2006 *John Moores Liverpool Exhibition*, Walker Art Gallery, Liverpool*
1976 *Arts Council Collection 75/6 Exhibition*, Hayward Gallery, London*
1977, 1981, 1983, 1985 *Tolly Cobbold-Eastern Arts National Exhibition*, Fitzwilliam Museum, Cambridge (touring to venues in Great Britain)*
1977 *Graham Crowley, Christopher Hamer: Paintings*, Arnolfini, Bristol
*A Free Hand, painting and sculpture recently acquired by the Arts Council of Great Britain*, chosen by William Packer, Arts Council touring exhibition*
*Drawing in Action: an exhibition of contemporary drawings*, Ferens Art Gallery, Kingston upon Hull (touring to British venues)
1978 *Roger Bates, Graham Crowley, Clyde Hopkins*, Winchester School of Art
1979 *Open Attitudes: new painting and sculpture*, Museum of Modern Art, Oxford*
*Style in the 70s: a touring survey show of new painting and sculpture of the decade*, presented by *Artscribe*, Arnolfini, Bristol (touring to Roundhouse Gallery, London, Hobson Gallery, Cambridge and other venues)*

1980 *7 Artists*, Kettle's Yard Gallery, Cambridge (touring to The Minories, Colchester)
1981 *Contemporary Artists in Camden*, Camden Arts Centre, London*
1982 *South Bank Show*, South London Art Gallery, London
*Graham Crowley, Tim Jones*, Bluecoat Gallery, Liverpool
*Hayward Annual 1982: British Drawing*, Hayward Gallery, London*
*Four English Painters*, Gemeindegalerie, Emmen, Switzerland*
*Biennale de Paris*, Musée Moderne de la Ville de Paris*
1983 *Stroke Line and Figure: paperworks by sixteen artists*, Gimpel Fils, London*
*53 83: Three decades of artists from inner London art schools*, Royal Academy of Arts, London*
*As of Now: Peter Moores Liverpool Project 7*, Walker Art Gallery, Liverpool*
1984 *Playing Live*, Loseby Gallery, Leicester*
*The Image as Catalyst: the younger generation of British figurative painters*, Ashmolean Museum, Oxford*
*The Proper Study: contemporary figurative paintings from Britain*, Lalit Kala Akademi, Delhi, India (touring to Jehangir Nicholson Museum of Modern Art, Bombay)*
*1985 10 Years at AIR: A Retrospective*, AIR Gallery, London*
*Still Life, A New Life: contemporary approaches to a traditional theme*, Harris Museum and Art Gallery, Preston (touring to Cartwright Hall, Bradford, Hatton Gallery, Newcastle upon Tyne, and other British venues)*
*Proud and Prejudiced*, Twinings Gallery, New York
*Artists Against Apartheid*, Royal Festival Hall, London
1986 *Figures and Myths for the late Twentieth Century*, Edward Totah Gallery, London
*Cityscape: the changing face of London*, Arthur Andersen and Company, London
*No Place Like Home: the ordinary made extra-ordinary in sculpture, painting and photography*, Cornerhouse, Manchester
1987 Edward Totah Gallery, London
*Comic Iconoclasm*, Institute of Contemporary Arts, London (touring to Douglas Hyde Gallery, Dublin, Cornerhouse, Manchester, and European venues)*
*Critical Realism: Britain in the 1980s*, Nottingham Castle Museum (touring to City Arts Centre, Edinburgh, Camden Arts Centre, London, and other British venues)*
*The Self Portrait: A Modern View*, Artsite, Bath (touring to DLI Museum and Art Gallery, Durham, Ferens Art Gallery, Hull and other British venues)*
1988 *Figuring out the 80s*, Laing Art Gallery, Newcastle upon Tyne*
*Cries and Whispers: new works for the British Council* collection, British Council tour to international venues
*The New British Painting*, Contemporary Arts Center, Cincinnati (touring to Chicago Public Library Cultural Center, Haggerty Museum, Milwaukee, and other USA venues)*
1989 *Images of Paradise for Survival International*, Harewood House, Leeds*
1990, 1991, 1992 *Summer Exhibition*, Royal Academy of Arts, London
1990 *Print News*, Oriel, Cardiff, and Chapter, Cardiff (touring to Welsh venues)
1991 *Art for Amnesty Auction*, Bonhams, Montpelier Gallery, London*

*10th Cleveland International Drawing Biennale*, Cleveland Gallery and Dorman Museum, Middlesbrough (touring to Oriel, Clwyd, Collins Gallery, Glasgow, and other British venues)*
1992 *Collector's Choice*, Bristol City Museum and Art Gallery*
1993 *Riverscape: four international artist residencies, River Tees, Cleveland*, various venues*
1994 *The First John Jones Open*, John Jones Gallery, London
*Back to Basics: a major retrospective*, Flowers East, London
1996 *Arthur Andersen Art Exhibition*, Arthur Andersen and Company, London
1997 *Summer Show*, Lamont Gallery, London
*Marking Presence*, Artsway, Sway, Hampshire*
1999 *The Flower Show: flowers in art in the 20th century*, Terrace Gallery, Harewood House, Leeds*
2000 *Summer Show*, Beaux Arts, London
*Order and Event: Landscape Now*, Michael Richardson Contemporary Art/Art Space Gallery, London
2000, 2001 *The Discerning Eye*, Mall Galleries, London*
2001 *London Underground*, Sungkok Art Museum, Seoul, South Korea*
*Summer 2001*, Beaux Arts, London*
2002 *Summer 2002*, Beaux Arts, London*
*Jerwood Painting Prize*, Jerwood Space, London, and Waterhall Gallery, Birmingham*
2003 *Local Colour*, King's Lynn Arts Centre
2004 *Graham Crowley, Ronnie Hughes and David Quinn*, West Cork Arts Centre, Skibbereen, Ireland
2009 *Home Truths: artists' images of where we live*, Harewood House, Leeds

**Public collections**
*London unless stated otherwise*
Arts Council Collection
Auckland Art Gallery Toi o Tāmaki, New Zealand
Basildon Arts Trust, Essex
British Council
Castle Museum, Nottingham
Contemporary Art Society
Ferens Art Gallery, Hull
Gray Art Gallery and Museum, Hartlepool
Imperial War Museum
Ipswich Museum
Kettle's Yard, University of Cambridge
Kirkleatham Museum, Redcar
Middlesbrough Institute of Modern Art
Leeds Education Authority
Leicestershire Education Authority
Northumbria University, Newcastle upon Tyne
Royal Albert Memorial Museum, Exeter
Victoria and Albert Museum

# Bibliography

**Published statements and writings by the artist**
'Conversation Piece: Graham Crowley, Christopher Hamer', *Arnolfini Review*, Bristol, November-December 1977
'Alan Miller in conversation with Graham Crowley and Stephen Farthing', *Alan Miller: selected paintings 1974-1984*, Ikon Gallery, Birmingham, 1984
Artist's statement, *The Image as Catalyst: the younger generation of British figurative painters*, Ashmolean Museum, Oxford, 1984
Interview, 'Under the Shadow', *FIRES*, London, 1 (summer 1986)
Artist's statement, *John Moores Liverpool Exhibition 15*, Walker Art Gallery, Liverpool, 1987
Artist's statement, *Riverscape: four international artist residencies, River Tees, Cleveland*, Cleveland Arts, Middlesbrough, 1993
Artist's statement, *John Moores Liverpool Exhibition 18*, Walker Art Gallery, Liverpool, 1993
Preface, *A walk to the Marshes: paintings by Julian Perry*, Austin/Desmond Fine Art, London, 1995
'Artist's Eye: Graham Crowley', *Art Review*, November 1998
Artist's statement, *John Moores Liverpool Exhibition 24*, Walker Art Gallery, Liverpool, 2006
Foreword, *Precious Things: a selection of contemporary painting*, Highlanes Gallery, Drogheda, Ireland, 2008
Interview with John Reardon, *ch-ch-ch-changes: interviews with artists who teach*, Ridinghouse, London, 2009

**Artists's book and illustrated editions**
Cover drawing, *Artscribe*, 40 (April 1983)
*Gogol's The Overcoat: Drawings by G.N. Crowley*, Institute of Contemporary Arts, London, 1984
Christopher Isherwood and Edward Upward, *The Mortmere Stories*, Enitharmon Press, London, 1994 (limited edition)
Stuart Hood, *Marquis de Sade for Beginners*, Icon Books, London, 1995

**One-man exhibition publications**
Brandon Taylor, 'Graham Crowley's new painting', *Graham Crowley: paintings and drawings*, AIR Gallery, London, 1982
Marco Livingstone, *Graham Crowley: Home Comforts*, Museum of Modern Art, Oxford, 1983
Martin Holman, *Graham Crowley: Table Manners, Stephen Farthing: Humble Friends* (exhibition guide), Edward Totah Gallery, London, 1984
William Feaver, 'Foreword', *Graham Crowley: In Living Memory*, Orchard Gallery, Derry, 1987
*Graham Crowley: Somewhere Else*, Edward Totah Gallery, London, 1991
Andrew Lambirth, *Graham Crowley: The Flower Show*, Lamont Gallery, London, 1998
Andrew Lambirth, *Graham Crowley: Familiar Ground*, Beaux Arts, London, 2001
Andrew Lambirth, 'The Evolution of an Artist', *Graham Crowley: are you serious?*, Ipswich Borough Council, 2002
William Feaver, 'New paintings', *Graham Crowley*, Beaux Arts, London, 2002
John Slyce, 'Sketches in Carbery: Graham Crowley's Calligraphy in the landscape', *Graham Crowley*, Beaux Arts, London, 2005

**Selected books and publications**
Ian Kirkwood, *Graham Crowley: drawings and paintings* (exhibition guide), Newcastle upon Tyne Polytechnic Art Gallery, 1978
Robert Ayers, *Playing Live* (exhibition catalogue), The Loseby Gallery, Leicester, 1984
Marco Livingstone, 'Graham Crowley', The Proper Study: *Contemporary figurative paintings from Britain* (exhibition catalogue), British Council, London, 1984
Sheena Wagstaff (ed.), *Comic Iconoclasm* (exhibition catalogue), Institute of Contemporary Arts, London, 1987
Brandon Taylor, 'Critical Realism', *Critical Realism: Britain in the 1980s* (exhibition catalogue), Nottingham Castle Museum, 1987
Teresa Gleadowe and Kim Winter (eds.), *Cries and Whispers: new works for the British Council collection*, British Council, London, 1988
Tony Godfrey, *Figuring out the 80s* (exhibition catalogue), Laing Art Gallery, Newcastle upon Tyne, 1988
Edward Lucie-Smith, Carolyn Cohen and Judith Higgins, *The New British Painting*, Phaidon Press, Oxford, 1988
Marco Livingstone, *British figurative painters of the '80s I*, Kyoto Shoin International, Kyoto, Japan, 1989
Marco Livingstone, *Pop Art: a continuing history*, Thames and Hudson, London, 1990
Jane Sellars, *The Flower Show: flowers in art in the 20th century* (exhibition catalogue), Harewood Visual Arts, Leeds, 1999
Andrew Lambirth, *Order and Event: Landscape Now* (exhibition guide), Michael Richardson Contemporary Art/Art Space Gallery, London, 2000
Sara White Wilson, 'Table Manners: Graham Crowley' in Stephen Farthing (ed.), *1001 Paintings you must see before you die*, Cassell, London, 2006

**Selected articles and reviews**
*London is place of publication unless stated otherwise*
'Gallery guide', *Observer*, 3 June 1979
William Feaver, 'The Seal of Approval', *Observer*, 15 July 1979
Christine Newton, 'Modern Art: New Problems, The educational programme at MOMA', *Oxford Art Journal*, 3 (October 1979)
William Feaver, 'The Liverpool lottery', *Observer*, 30 November 1980
William Feaver, ''81 for the road', *Observer*, 12 April 1981
Richard Cork, 'Inter-city dreamworld', *Evening Standard*, 1 October 1981
William Feaver, 'Evasive tactics', *Observer*, 7 February 1982
John McEwen, 'Dibbets, Crowley', *Art in America*, New York, summer 1982
John Roberts, 'Graham Crowley, AIR Gallery, London', *Aspects*, 19 (summer 1982)
William Feaver, 'Peep-shows from Paris', *Observer*, 12 December 1982
Richard Cork, 'Bird cure at the Brompton', *Evening Standard*, 17 February 1983
Paul V. Kopeček, 'Tolly Cobbold-Eastern Arts', *Aspects*, 23 (summer 1983)
Marina Vaizey, 'Picking up the pieces', *Sunday Times*, 12 June 1983
Waldemar Januszczak, 'A nasty shock for the still-life', *Guardian*, 10 June 1983
William Feaver, 'Boom and bust', *Observer*, 12 June 1983
Robert Ayers, 'Graham Crowley', *Artscribe*, 40 (April 1983)
John McEwen, 'Influenced', *Spectator*, 30 July 1983
John McEwen, 'A brush with the young masters', *Sunday Times Magazine*, 23 October 1983
Robert Ayers, '"As of Now" at the Walker Art Gallery…', *Artscribe*, 45 (February-April 1984)
William Feaver, 'One True Faith', *Observer*, 22 July 1984
Nigel Pollitt, 'Graham Crowley: Nightlife', *City Limits*, 22 July 1984

Tony Godfrey, 'Graham Crowley and Stephen Farthing', *Art Monthly*, November 1984
Adrian Lewis, 'Graham Crowley and Stephen Farthing at Edward Totah', *Artscribe*, 49 (November-December 1984)
E.H., 'Graham Crowley, Totah-Stelling', *ARTnews*, New York, summer 1986
William Feaver, 'Mutation in the meadow', *Observer*, 1 February 1987
William Feaver, 'Comic-strip heroes', *Observer*, 19 July 1987
Marina Vaizey, 'The British scene shows signs of life', *Sunday Times*, 11 October 1987
William Packer, 'An idiosyncratic look at the one-man-show', *Financial Times*, 13 October 1987
Brandon Taylor, 'Graham Crowley', *Arts Review*, 23 October 1987
'First of a new generation', *Llandaff Gem*, Wales, 21 November 1987
Judith Higgins, 'Painted Dreams', *ARTnews*, New York, February 1988
David Lee, 'The state of modern art', *The Times*, 16 June 1988
William Feaver, 'London: Graham Crowley', *ARTnews*, New York, March 1988
Marco Livingstone, 'In Every Dream Home a Heartache', *Art & Design*, IV, 9/10 (1988)
William Feaver, Graham Crowley, *Modern Painters*, II, 3 (autumn 1989)
William Feaver, 'Women with gloves off', *Observer*, 8 October 1989
William Feaver, 'Sticks, stones and a few gems', *Observer*, 9 June 1991
William Feaver, 'If you go down to the woods today', *Observer Magazine*, 1 September 1991
'Battling with the elements for the sake of art in Teeside', *Darlington and Stockton Times*, 2 May 1992
Alison Ferst, 'Essex man's artistic brush with Cleveland', *Evening Gazette*, Hartlepool, 27 March 1992
John McEwen, 'Death by Dairy Milk', *Sunday Telegraph*, 3 July 1994
William Feaver, 'Congratulations to a blotter on the landscape', *Observer*, 24 October 1993
'Lessons with Old Masters', *Hampstead and Highgate Express*, 15 July 1994
Tim Hilton, 'Some are more equal than others', *Independent on Sunday*, 24 July 1994
Andrew Lambirth, 'Graham Crowley', *Galleries*, XIII, 1 (June 1995)
Nicholas Usherwood, 'Graham Crowley', *Modern Painters*, X, 2 (summer 1997)
William Feaver, 'Emigrating to avoid your critics seems a little extreme', *Observer*, 12 June 1997
John McEwen, 'The poetic beauty of an unhinged gate', *Sunday Telegraph*, 8 June 1997
John McEwen, 'Remembering a Jekyll-and-Hyde', *Sunday Telegraph*, 15 November 1998
Julian Perry, 'Graham Crowley', *Galleries*, XVIII, 9 (February 2001)
Craig Burnett, 'Graham Crowley', *Modern Painters*, XIV, 1 (spring 2001)
John McEwen, 'Painting is still not dead', *Sunday Telegraph*, 19 May 2002
Rebecca Geldard, 'Graham Crowley: Beaux Arts', *Time Out*, 19 February 2003
Sue Hubbard, 'Graham Crowley at Beaux Arts', *Independent*, 14 March 2005
Vanessa Thorpe, 'Low morale devastates art colleges', *Observer*, 10 February 2008
Aidan Dunne, 'Paintings to be seen in the flesh', *Irish Times*, 1 October 2008
Carol Gilbert, 'Graham Crowley speaks of his early determination to paint', *Southern Star*, Skibbereen, Ireland, 7 February 2009

The artist dedicates this book to Sally, Robin and Pearce

THE HENLEY COLLEGE LIBRARY

First published in 2009 by Lund Humphries in association with Broken Glass, London.

www.brokenglassbooks.com

Lund Humphries
Wey Court East
Union Road
Farnham
Surrey GU9 7PT
UK
and
Lund Humphries
Suite 420
101 Cherry Street
Burlington, VT 05401-4405
USA

www.lundhumpries.com

Lund Humphries is part of Ashgate Publishing.

British Library Cataloguing-in-Publication Data.
A catalogue record for this book is available from the British Library.

ISBN 978-1-84822-024-9

All rights reserved. No part of this publication may be reproduced or transmitted in any form or by any means, electronic or mechanical, including photocopy, recording or any other information storage and retrieval system, without prior permission in writing from the publisher.

Every effort has been made to contact photographic copyright holders. Any omissions are inadvertent and will be corrected in future editions if notification is given to the publisher in writing.

Text © Martin Holman 2009.

All works by Graham Crowley © 2009 the artist. Images of work are illustrated courtesy of the artist unless otherwise stated.
**www.grahamcrowley.com**

Edited by Martin Holman and Graham Crowley.
Photography by Graham Cooper, John Martin and Phil Pound.
Design by David Bloomfield.
Printed by Dr Cantz'sche Druckerei GmbH & Co. KG, Germany.